LEGENDARY LOCALS

— OF —

NEW BRITAIN
CONNECTICUT

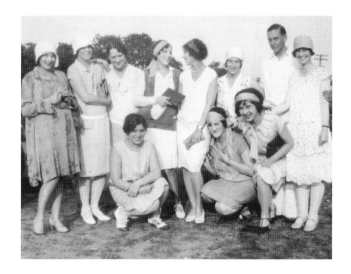

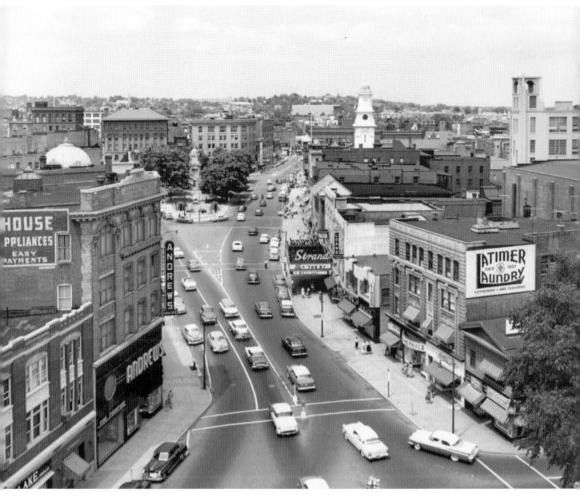

Downtown New Britain, Mid-1950s
This photograph, taken from the clock tower of South Church, offers a northerly view along Main Street. While recognizable as New Britain by young and old alike, this scene brings back fond memories to older residents. The Strand Theater (center), for example, was the most popular theater in the city, and it was certainly the most sorely missed. Calls to "remember the Strand" are often heard in the city when redevelopment or demolition projects are being considered. Other landmark structures that have since been removed include the First Church of Christ (top, center) and the dome of the Savings Bank of New Britain (left). (Local History Room, New Britain Public Library.)

Page 1: New Britain Normal School Glee Club, 1927
The glee club of the State Normal School in New Britain was made up of accomplished singers and musicians who organized and participated in concerts and events in New Britain and around the state. In this photograph of early-20th-century New Britain life, these young women and man represent the first generation of that century. While the State Normal School (today, Central Connecticut State University) had just moved from downtown to the rural northeastern reaches of the city, the glee club helped maintain ties to downtown residents through concerts and activities. The club is also a fine example of New Britain's dedication to culture and the arts, even during the height of industrialization. (New Britain Historical Society.)

LEGENDARY LOCALS

OF

NEW BRITAIN

CONNECTICUT

AMY MELISSA KIRBY

LEGENDARY
LOCALS

Legendary Locals is an imprint of Arcadia Publishing
Charleston, South Carolina

Printed in the United States of America

Library of Congress Control Number: 2013942811

For all general information, please contact Arcadia Publishing:
Telephone 843-853-2070
Fax 843-853-0044
E-mail sales@arcadiapublishing.com
For customer service and orders:
Toll-Free 1-888-313-2665

Visit us on the Internet at www.arcadiapublishing.com

Dedication
This book is dedicated to Anna Mae Jacobs—my mother, my supporter, my inspiration. I regret that you were taken too soon to realize my accomplishments.

On the Front Cover: Clockwise from top left:
Chief Clifford J. Willis, New Britain Police (Courtesy of New Britain Police Department; see page 71), John Fredericks, "Uncle Sam" (Courtesy of Sylvia Fredericks; see page 124), Dexter Fellows, Wild West Show and circus front man (Courtesy of New Britain Historical Society; see page 39), Anthony Bianca, World War II veteran and civic leader (Courtesy of Anthony Bianca Jr.; see page 69), Theodore "Teddy" Wilson, jazz pianist (Library of Congress; see page 41), Frederick T. Stanley, industrialist and first mayor (Courtesy of Local History Room, New Britain Public Library; see page 25), Meta Grimm-Lacey, descendant of the Brothers Grimm (Courtesy of Local History Room, New Britain Public Library; see page 43), Connie Collins, first African American city official (Courtesy of City of New Britain; see page 70), Isaac Lee, founding member of New Britain Society (Courtesy of New Britain Historical Society; see page 13).

On the Back Cover: From left to right:
Hoffmann's Bakery owners, celebrating 50th year of business (Courtesy of Local History Room, New Britain Public Library), Bassett-Doen-Hart family get-together (Courtesy of Local History Room, New Britain Public Library; see page 110).

CONTENTS

ACKNOWLEDGMENTS

The author acknowledges with much gratitude the prior work of local historians, for creating much of the foundation for this work. For sharing photographs of and stories about New Britain's legends, I wish to thank Anthony Bianca Jr., Alderwoman Tonilynn Collins, Sylvia Fredericks and family, Dr. Christopher Winship, Chris Chamberlain-Puffer, Chief James Wardwell and the New Britain Police Department, Pat Watson and the staff of the Local History Room of the New Britain Public Library, and fellow members of the New Britain Historical Society. I also wish to thank the many people of New Britain who have shared their personal stories and experiences with me over the years. Unless otherwise noted, the images in this volume appear courtesy of the New Britain Historical Society (NBHS), the Local History Room of the New Britain Public Library (NBPL), and the Police Museum collection of the New Britain Police Department (NBPD).

INTRODUCTION

New Britain was founded and named by colonists who fondly remembered their homeland, despite its intolerance toward their religion. Although in this way it appears to be a typical New England town, New Britain is, in fact, unique. The men and women of New Britain created their modern, cosmopolitan, industrialized city despite a lack of resources that spurred the growth of other industrial towns. New Britain was destined to stand out not because of its natural advantages, but because of the ingenuity and determination of its people.

Historians often note that it was improbable for the area now part of New Britain to be a viable settlement. The area featured extensive swamplands, rocky hills, and meager streams. Even the Mattabesset Indians—the Tunxis, the Wangunks, and the Quinnipiacs—had not a single village here, but, rather, they considered this their hunting grounds. It was not long after the establishment of Hartford that a group of Tunxis solicited settlers from Hartford to purchase and settle land on the bend of a nearby tributary of the Connecticut, known as Tunxis Sepus. The town of Farmington was established in 1645, the first inland settlement west of the Connecticut River. It would soon be the largest town in the colony. Although initially settled miles to the north, this would be the mother town of New Britain.

For the first few decades, Farmington residents remained in their principal village, living in relative harmony with the Tunxis, who helped protect them during King Philip's War. Eventually, a highway laid out between Hartford and New Haven brought attention to the swampy wilderness of southern Farmington. A few men were granted tracts of land in this area, generally out of some sort of civic service to the colony. A wealthy merchant, Capt. Andrew Belcher, saw this land as an opportunity and purchased large tracts from the original owners. He made some improvements—roads, cleared farmland, and a few structures—and offered lots with easy terms for settlers. In 1686, Richard Seymour and others from Farmington chose to settle in the "Great Swamp" along a path that they named "Christian Lane." Beginning as a fort, the settlement began spreading out as Belcher sold his tracts. The population grew quickly, and in 1705, the community established itself as an independent ecclesiastical society, the Great Swamp Society. Eventually renamed Kensington Society, it began in the mid-1720s to experience disagreements between different sections of the parish. A group of residents in the northernmost portions of the community petitioned the Connecticut General Assembly to create their own ecclesiastical society, which they were granted. This was the establishment of New Britain Society in May 1754.

A hardy and capable lot, the first residents of New Britain sustained their relatively isolated agrarian village and maintained their devotion to church and work. Most were farmers, although typical Colonial-era businesses began to spring up. Blacksmiths and tinsmiths provided locals with tools and utensils for farming and domestic work. A couple of stores came into existence to provide trade for goods imported from the rest of the colony or beyond. Taverns brought in some money from travelers on the principal roads, and there were a few small sawmills and gristmills that used the small streams found in the parish.

Blacksmiths saw the success of the tinsmith, and some had already created a line of products for farming, milling, and domestic use. But without brass fittings and knobs, they could not compete with the fancier goods from Massachusetts. So, three blacksmiths' sons went abroad to learn the brass-making trade. Upon their return in 1799, James North Jr. and Samuel Shipman partnered in what is considered the first manufacturing venture in New Britain, the production of brass sleigh bells. North and Shipman soon became one of the principal manufacturers of brass goods, selling them all over the colonies via the horse-drawn wagons of Yankee peddlers, and continually diversifying to survive the first decades of the 19th century. By the 1850s, other local families began to follow suit as industrialists or investors, and even some men from outside the area saw the opportunity here. This began a century of almost steady industrial growth, earning New Britain the title "Hardware Capital of the World."

It was not only determined growth and diversification of products that made New Britain great. To overcome the lack of waterpower, Frederick Stanley was the first to employ a steam engine. In similar spirit, New Britain industrialists were prolific in patenting not only their goods, but also tools and technologies of industry. The success of New Britain's factories made this city a destination for immigrants from around the world. Industry and population exploded, and New Britain became a town in 1850, and then a city in 1871. The residents and city leaders designed, alongside the factories, a great city of beautiful architecture, towering churches, and lush parks. The tough life of factory work was balanced by sports activities, civic societies, the arts, and shopping. By the end of the 19th century, New Britain was an industrial giant and probably one of the most cosmopolitan cities between New York and Boston. And it continued to grow into the 20th century. When, in World War II, the War Department called for production of armaments and equipment for the armed forces, New Britain's great factories were ready to answer the call. Men and women were not only glad to have a steady job, but they were also proud of the work they did for their nation.

When the war ended, most manufacturers converted to their prewar goods. Some companies survived this expensive process, while others ran into trouble. Meanwhile, across the nation, new expressways were being laid out to give people and businesses access to the increasing trend of automobile travel and truck shipping. With a booming economy, New Britain's manufacturers saw the time for expansion, but they had no highway access and no land left in the middle of the city. This problem was at first ignored by city leaders, and initial plans for expressways through the city were turned down. They could see no reason to bisect the city and bulldoze homes when the factories were doing fine as they were. After all, big manufacturing built this city, so did they not have an unbreakable tie to the city? As it turns out, beginning in 1950, industry leaders began telling city leaders that, frankly, they had no obligation to the city. Tax breaks and better highway access offered by other locales were too good to pass up. By the end of the decade, the first big companies began closing their plants, commencing an exodus that would change the face of the city. Civic leaders and residents could see the consequence of inaction. Beginning with the ceremonial swing of a sledgehammer in 1961 by Mayor Julius Kremski, the period of redevelopment began.

Redevelopment involved a few initiatives: better transportation, more room for manufacturers to grow, and conversion of industrial zones to commercial use. This began with a feverish demolition of buildings, including not only the big factories but, unfortunately, a number of historic buildings. Not one, but two expressways were laid out through the city, further transforming and obliterating the landscape in the name of modernization. A few industrial zones were created on the outskirts of the city, but in most cases the companies either found a better offer or the city could not come through with a deal. What was left when the dust settled was a new city. Of the large manufacturers, only Stanley Works remained, keeping some of its operations as well as its headquarters in New Britain. Routes 72 and 9 cut travel time to surrounding towns. Huge shopping and office centers sprawled where the dingy brick monoliths once stood. And outside of downtown, the skyline was now dominated by the numerous church steeples and towers, surely making for a more pleasing view. Those not enjoying the scene were workers who had lost their jobs. While smaller manufacturers continued to operate, overall, available jobs dwindled due to a more diverse economy, which continues to this day.

Today, New Britain is in many ways similar to other postindustrial towns in its evolution during the 20th century. While the landscape and economy has changed, there remain definite advantages owing to New Britain's great industrial history. Cityhood, for instance, would not likely have taken place, and without industry, New Britain could very well have remained a part of the towns of Berlin or Farmington. Ethnic diversity is still a major characteristic of New Britain, thanks to the industries that attracted immigration. And while New Britain struggles to redefine itself in the 21st century, its residents still enjoy the pride of their city and their heritage, which in many ways make New Britain a legend in Connecticut.

That being said, let us consider some of the local legends of New Britain—the people who have found themselves in local lore for one reason or another. Legends include the most esteemed city leaders and the most commonplace people to be found in written and oral accounts of the city. Legends include lifetime residents, those who spent a short time here, and those who left at one point to make a name

for themselves. With its long and colorful history, New Britain has yielded legends in all aspects of life. The founding families are spoken of for their courage to start this new community and to help fight for independence and democracy. Veterans from all wars—from Colonial times to this day—yield a variety of legends. Industrialists and their spirit of capitalism and philanthropy brought industry and so much more to this city. Artists and entertainers of all types either bestowed their works here or have at one time called New Britain home. The story of the immigrant is very important, and there are certainly those who have become a legend for what they accomplished here or abroad. Sports has always played an important role, and some very notable athletes have become a part of the city's story. Finally, every city attracts crime—some typical and some significant for a particular reason—as well as the remarkable people and institutions of law enforcement. These people, along with institutions of all kinds made up of people from all walks of life, will be presented here for the reader's consideration and to help preserve the history of New Britain's legendary locals.

CHAPTER ONE

Colonials and Revolutionaries

The founding families of 18th-century New Britain were indeed colonials *and* revolutionaries, in the best sense of these terms. They were colonials, in that they came in the spirit of settling new land and creating a new life. They were revolutionaries in terms of their ideals in religion and government, both of which opposed a staunch and merciless establishment. It is with this in mind that this chapter shall consider the people of the first half-century of New Britain.

Each individual in a colony had certain duties expected of them—duties followed enthusiastically and in accordance with the tenets of Puritanism and colonialism, if not survival. As the original inhabitants were farmers, most strove to maximize their personal or family landholdings, their farm production, and their influence in the community. The first divisions of New Britain, the quarters, were based on both the original hamlets and the prominence of family land ownership. Stanley Quarter, which included most of the northern half of New Britain, was dominated by members of the Stanley family. A Hart Quarter, similarly dominated by the Harts, was situation largely to the southwest. The Andrews family settled and worked largely in the northwest, and some literature notes an Andrews Quarter. The families in the eastern quarter were more diverse, and thus this was simply called the East Street Quarter. At the same time, roads were constructed to connect the four towns that bounded New Britain. The parish therefore saw travelers, and taverns were found in Stanley, Hart, and East Street Quarters early on.

The first inhabitants were classified largely by their professions, their civic duties, and their military rank. This was a largely homogenous lot in terms of ethnicity; nearly all were from England, save a few Irish and Scottish families. A few families owned slaves. However, labor was considered honorable, and the wealthier and poorer classes performed the same tasks. Whether it was clearing land, harvesting crops, or digging out after blizzards, men could be seen almost every day, with the exception of the Sabbath, working alone or together for the good of their community. Women were just as industrious and diligently performed the work expected of them to keep their homes in order and their husbands healthy. Most of the early families owned and worked farms for subsistence and for trade. However, some families and individuals chose to pursue other professions, in which case, farming was a secondary operation or performed on a household scale.

Generally, the first businesses were run out of family homes or outbuildings on the farms along East Street. Taverns served as public meeting places and offered rest for travelers. The first stores were on East Street. One was kept by Joseph Clark in a house still standing near Central Connecticut State University. The other store was kept by Elnathan Smith farther to the south. These stores were places of trade, often providing supplies from the outside world to the parishioners. The other principal occupations in 18th-century New Britain were physicians, tinsmiths, blacksmiths, leather tanners, and workers at sawmills and gristmills. Some of the first tinsmiths—Erastus Lewis, William Smith, William and Edward Paterson, and Thomas Lee—began manufacturing the first "luxury" goods in New Britain, selling them in their stores or abroad. These men were considered pioneers in the region for initiating this industry

as well as the profession of the Yankee peddler. This innovation spurred similar activities by blacksmiths, leading to the beginnings of industry by the close of the 18th century. Timothy Stanley, who lived on Stanley Street, nearly across from the Noah Stanley Tavern, was known for being the first shoemaker. In addition, he had a tannery for leather. James Judd ran the principal sawmill for New Britain, which supplied the growing village and exported lumber for many decades. Farther south, the Harts operated a gristmill, which produced flour and meal from grains grown on New Britain's farms.

Civic duties in New Britain, in the town of Farmington, and at the colony (and, later, state) government were in many cases performed in addition to the person's principal occupation. There were, however, a few men in New Britain who were noted for lengthy terms as judges and magistrates. Additionally, a number of men were assigned military ranks as part of the "trainband" of the colonial militia, and many of them fought in the French and Indian War. Indeed, many of the men mentioned with distinction in the history books had a military title as well as a variety of civic titles in local or colonial government.

On the eve of the Revolutionary War, when the British blockaded Boston Harbor, a few men immediately headed to Boston to join the Continental army, and the residents who stayed behind donated food and provisions to the residents of Boston. The following year, when British ships aimed their cannons at the Connecticut shoreline, the militia immediately assembled and prepared to move out. Col. Gad Stanley, the head of one company, would go on to be a war hero. At the disastrous Battle of Long Island, Stanley was instrumental in leading his unit safely past the British. Upon his return, Gad Stanley resumed his life as a farmer. He was an official in just about every local civic office and served as town representative in the state legislature. No known portrait of Stanley survives to this day.

While this chapter is sorely short of portraits, it is hoped that this introduction makes clear that, in many ways, these, the founding members of New Britain, are themselves local legends. In a city where physical reminders of this era are few, anecdotes still abound alongside the legends that will be conveyed in the rest of this volume.

Col. Isaac Lee (1716–1802)

Lee, a founding member of the Ecclesiastical Society of New Britain, has the distinction of selecting the name of the new parish in 1754. He was the grandson of Capt. Stephen Lee, a patriarch of the Great Swamp Society, whose land was bordered by East, Main, and East Main Streets. Colonel Lee's father and uncle had provided portions of the farm to the society for the meetinghouse and burying ground. Lee built one of the first houses on Main Street, near the foot of Dublin Hill, in 1745. He was known around town as a very strong and athletic man, reputed for his ability for throwing both barrels of cider and fellow wrestlers with ease. Despite this, he was not unknown to be seen around the village wearing the fineries depicted here. During the wedding to his wife, Tabitha, Colonel Lee became aware of a group of rambunctious young men who wished to subject her to "bride-stealing." This was an old-world custom in which a group of men and women would carry off a bride and keep her out all night at the taverns. As described in Emma Hart Willard's 1840 poem, Lee recognized the leader of this group, warned his bride of the impending prank, and single-handedly fended them off when they came to take her. It was for his civic duties, family heritage, and physical stature that he was treated with the utmost of reverence. Only Colonel Lee and Rev. John Smalley could expect passersby to remove their hats and gesture with obeisance. When the Revolutionary War came, it was Lee alone who quelled a dangerous confrontation between Smalley (an outspoken royalist) and the rallying men. As a member of the colonial assembly and then the state assembly, Lee represented his community and the entire town of Farmington when he took the "oath of fidelity of allegiance" to the United States in 1776. Colonel Lee joined the state convention at Hartford in 1788 to determine the adoption of the US Constitution. He held the office of justice of the peace until he was 81 years old. (NBHS.)

Rev. John Smalley, DD (1734–1820)

After the establishment of New Britain Society in 1754, the founders began an arduous search for a pastor to begin their church. This was crucial, as the society needed a preacher who held their religious views but who could also serve as a civic leader. In 1757, they finally happened upon Rev. John Smalley, who had just graduated from Yale and was eager to start his first assignment. He began preaching and was accepted and ordained by April 1758. While cold and harsh in temperament, he quickly earned the respect and admiration of New Britain, due to his knowledgeable, eloquent, and opinionated style. His advice was valued on all church questions, and he was highly sought-after by churches and associations all over New England. He also served as a teacher, his most famous student being Oliver Ellsworth, future chief justice of the US Supreme Court. While known to run a frugal and thrifty household, Smalley himself took full advantage of his sizable salary, wearing the finest velvet and silk from England. When out in the village, he could be seen surveying his parish from horseback, nodding to the men of his flock, who removed their hats and paid him reverence. He was also known for his conservatism in politics, social life, and church practices—all of which he unapologetically injected into his sermons. While most New Britain residents regarded him with reverence and cheerful obedience, some of his sermons created controversy, as they suggested a royalist stance. As the Revolution approached, Smalley warned that disaster would come if the colonies abandoned their king. One morning, news of British ships bombarding the port of Stonington reached the congregation during a meeting. When a company of soldiers gathered to make preparations, Smalley shouted at them, "What? Will you fight your King?" Col. Isaac Lee helped quell the ensuing melee and convince Smalley to publicly concede to the will of his flock. When peace was finally restored and the colonies gained their independence, Smalley rejoiced as much as anyone and continued to serve New Britain for a total of 63 years. His last sermon was delivered on September 26, 1813, and he passed away in 1820 at almost 86 years of age. (NBHS.)

Maj. Gen. John Paterson Jr. (c. 1744–1808)
John Paterson was born in Wethersfield to a family of Scottish emigrants. When New Britain Society was formed, a portion of the family land, that belonging to John's father, John Paterson Sr., became part of this society. John graduated from Yale in 1762, the same year that his father died; John then moved into his father's estate. He was good friends with Dr. Smalley and his student Oliver Ellsworth. In New Britain, John Paterson was a teacher, attorney, and justice of the peace, and he was considered a good friend to all of his neighbors. In 1774, he moved to Lenox, Massachusetts, along with his wife and father-in-law, Josiah Lee. Having immediately earned the respect of that town, he was appointed to the provincial congress. At the start of the Revolution, he raised a regiment and was early in the field, serving with honor throughout the war. He was not only noted for excellent military service but was also honored with the friendship of George Washington, and he earned the rank of brigadier general. Paterson was present at the surrender of Gen. John Burgoyne and the Battle of Monmouth, and was one of the senior officers selected by Washington to try British spy Maj. John Andre in 1780. At the end of the war, in 1783, Paterson was promoted to major general in the Continental army. He later moved to New York, serving again as a court justice, then was elected to the New York State Legislature. He served as a representative in Congress from 1803 to 1805. Near his place of birth on East Street in New Britain, a marker honors John Paterson for his service to the nation. In the center of the town of Lenox, there is another monument to his memory, and on a memorial tablet in a Lenox church, it is written, "His love of country was unbounded, his public spirit untiring." (NBPL.)

Home of John Paterson Sr.
John Paterson Sr., a well-educated man and the first church deacon in New Britain, resided on East Street. He enlisted with the British Army during the Seven Year's War. Prior to being called to duty, Major Paterson made out his will, explaining in it the danger of his undertaking. He died after the Battle of Havana in 1762, the same year that his son John graduated from Yale College. (NBHS.)

Home of Deacon Josiah Lee
Josiah Lee built his home on what is now the corner of East and Smalley Streets. He and Dr. Isaac Lee inherited the extensive lands of their father, Capt. Stephen Lee. Both donated some land to the society for the meetinghouse, burying ground, and the road that would become Smalley Street. Josiah Lee sold this house, and it eventually became the home of Rev. Newton Skinner, second pastor of First Church. (NBHS.)

First Storekeepers of New Britain

Shown here are the stores and homes of Joseph Clark (above) and Elnathan Smith (below). Clark and Smith provided a means for local trading of farm products for groceries and dry goods. Clark was contracted to supply finishing materials—trimmings, windows, and paint—for the first meetinghouse. His was a smaller store, although he and his descendants were instrumental in developing the industrial area of northern East Street Quarter. The Clark home still stands on a hill near Central Connecticut State University, overlooking the small manufacturing firms in this remote corner. Smith had a larger store, located in what was the more populated southern East Street Quarter. Smith was active in civic affairs, even serving as constable. By about 1805, the Lee family built a store on Main Street, and Clark and Lee simply could not compete. (Both, NBHS.)

New Britain's Tavern Keepers

Early New Britain had three main taverns: Joseph Smith's on East Street, Noah Stanley's in Stanley Quarter (above), and Elizur Hart's in Hart Quarter (below). Tavern keepers opened their homes to travelers and locals alike for food, drink, merriment, and accommodations. Hart often hosted society and civic meetings, and his tavern earned the nickname "the State House." At night, however, Hart was known among young men and women for hosting popular and scandalous parties. Noah Stanley certainly saw a fair amount of drinking, dancing, and gambling among his guests. However, Stanley also regularly hosted meetings of military and civic leaders to discuss affairs of the Revolution and the formation of the United States. The tavern of Joseph Smith (or "Landlord Smith") was a popular resort for officers during the French and Indian War and the Revolution. (Both, NBHS.)

Sarah Lee-Lankton (1696–1756)

Sarah Lankton, an obscure legend, left behind no known portrait, and there are only limited written descriptions, typical of the women of early New Britain. Daughter of Capt. Stephen Lee, she was married to John Lankton, and they had a son named John, who became a well-respected man known as Capt. John Lankton. Sarah died at the age of 59 in 1756, and she was the first person interred in the burial plot that had just been donated by her brothers, Dr. Isaac Lee and Deacon Josiah Lee. The grounds are now known as Fairview Cemetery. Among the other women of her generation, Sarah is the most discussed, because of her status as the first resident buried at Fairview. Beyond the dubious honor of her achievement at death, Sarah Lankton can be seen as a typical, yet quite remarkable, woman in New Britain during the Colonial and Revolutionary eras.

A successful and largely self-sufficient Puritan homestead involved numerous labor-intensive duties. Certainly, the division of labor put women squarely in charge of the house and hearth, and women (that is, the mother and any girls) were expected to take care of the father and any working boys. Housework could be as dangerous as farm work, with many a woman, girl, or small child burned by the hearth or an oil lamp. But women knew that this role in the family was honorable and sanctified; the men relied on their wives as much as wives depended on their husbands. Even the day of the Sabbath, on which women had a break from the drudgery of household chores, the wife would ensure that everyone was ready to go to the meetinghouse – proper clothing, perhaps some food and water, and foot stoves full of coals if it was a cold day. The Puritan homemaker was not meek and subdued, as the feminist movement would suggest. Rather, women like Sarah Lankton were extremely important to the survival of their household and, therefore, the survival of remote communities like early New Britain. (NBHS.)

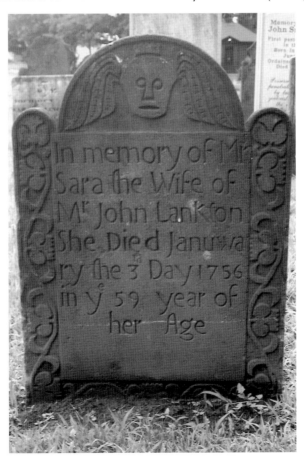

Home of Elijah Hart III (1759–1827)
Capt. Hart had a large farm and gristmills in Hart Quarter. The mills produced corn meal. One of the first exporters, Hart sold his goods via the coastal trade routes. He fought in the Revolutionary war and was present at the surrender of General Burgoyne. Capt. Hart began his retirement by age 68, but, sadly, his life was cut short by the sting of a bee. (NBPL.)

Home of Gad Stanley Jr. (1776–1820)
Gad Stanley Jr. was named in a bit of prose written by his father while away at war: "If he appear a likely lad, it might be well to name him Gad." Gad Jr. built his house right next to that of his father. Legend has it that these two homes were used for the Underground Railroad, and the current owners have found entrances to an ancient passageway between them. (NBHS.)

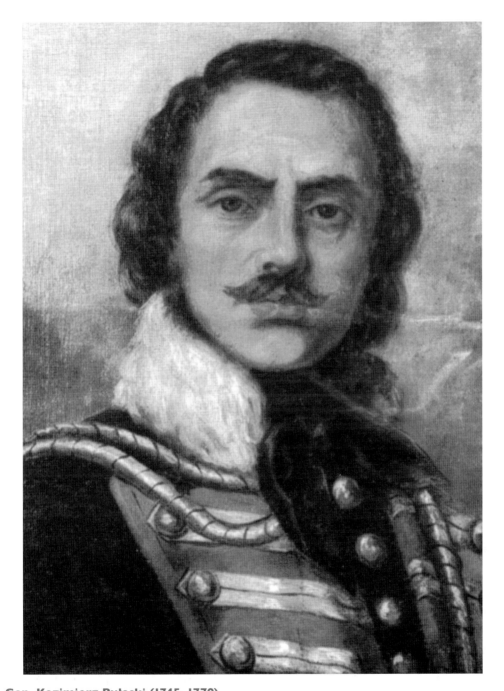

Gen. Kazimierz Pułaski (1745–1779)
New Britain greatly reveres this revolutionary hero of both Poland and America. A nobleman of Warsaw, Pulaski became active in a revolution against Russian domination. Forced into exile, he came to America to serve in the Continental army. He once saved the life of George Washington, and he gave his life leading American soldiers against the British. Pulaski has been commemorated by New Britain with a monument and memorial park in the Little Poland district, Pulaski High School (1961–1982), and, since then, Pulaski Middle School. (NBHS.).

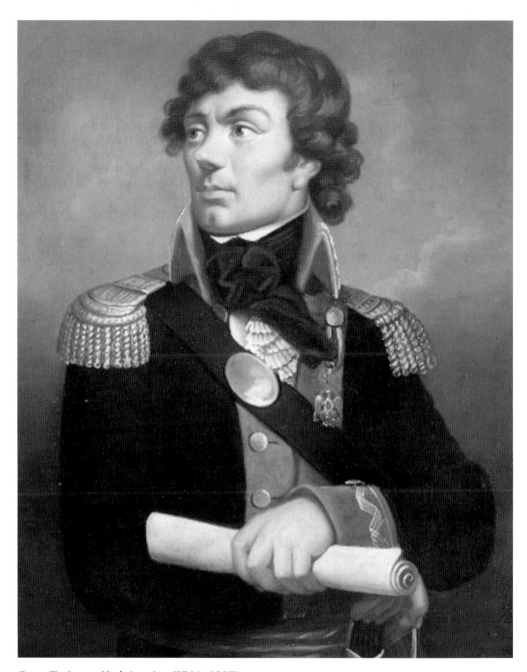

Gen. Tadeusz Kościuszko (1746–1817)

Like Pulaski, Kościuszko is a national hero for his contributions to the fight for independence for Poland and Lithuania. He also took part in the American Revolution, during which he was noted for building modern fortifications. Afterward, Kościuszko returned to the Polish-Lithuanian Commonwealth to lead the 1794 Kościuszko uprising, during which he was captured. He is commemorated in New Britain with a monument and memorial park adjacent to Pulaski Park in the Little Poland district. Many also see his name on the Tadeusz Kościuszko Memorial Highway section of Route 72, between Route 9 and Corbin Avenue. (National Museum in Warsaw.)

CHAPTER TWO

The Building of a Modern City

Around the start of the 19th century, New Britain began a transformation that, in many ways, led it to become a city. While it was not until 1850 that New Britain even achieved town status, it certainly had the resources to do so. In 1785, the three parishes of the Great Swamp area, Kensington, New Britain, and Worthington, joined together to create the Town of Berlin in 1785. While growth was slow at first, New Britain would be on track to outpace its neighboring villages and become a town and a city on its own in less than a century.

The 19th century was a period of great growth for New Britain—in population, in industry, and in commerce. The first few decades could probably best be described as a time of reorganization—new roadways, new commercial and industrial areas, and a general change in economy, from mainly agriculture to manufacturing. Main Street, although still flooded by a stream flowing into a swamp on the east side of the street, was being eyed as the new center. The number of homes and businesses on Main Street grew, from about a dozen to at least three times that by 1840. Stores, taverns, and other businesses began moving to Main Street. Although the original meetinghouse and green area grew into a popular commercial district, Main Street grew into a downtown area with its own central green.

The economy became more dependent on regional and world events; thus, the disruptions in manufacturing during the War of 1812 and the Panic of 1837. At the same time, however, industrialists were learning how to weather such disruptions. Industrial growth began in earnest in the 1840s, throttled perhaps only by the speed at which goods could be distributed by horse and wagon, the only available means of transportation at the time. It was after 1850, the year New Britain gained full railroad access and the year it became a town, that the most profound changes took place. These changes involved not just industry, but included the development of schools, a library, parks, waterworks, and all of the facilities necessary for a modern city.

Residents began increasingly taking part in making New Britain not just a factory town, but a modern cosmopolitan center. People of all classes formed social, benevolent, scientific, and arts societies. Although this was the dawning of the Gilded Age, when captains of industry became as wealthy as kings, most of New Britain's industrialists took an active part in their city. The wealth that these factories brought to some families was put into roads, a hospital, parks, monuments, the arts, and municipal facilities. Today, the legacies of these families can be seen in the parks and facilities that still bear their names.

By the end of the 19th century, mammoth factories surrounded the downtown area. Immigrants poured into the city to take the numerous jobs offered in the factories, to start their own small businesses, or even to chase the dream of becoming a tycoon in industry or finance. This influx became apparent by the faces on the street, the windows of the stores, and the churches, cathedrals, and temples that towered over the neighborhoods. And while many of the founding families still controlled much of the economy and local government, the face of New Britain was no longer of exclusively Puritan stock, but of increasing diversity as it became a destination for immigrants from around the world.

The first decades of the 20th century were ones of great economic prosperity for New Britain. Not only manufacturing, but also banking, investing, and insurance became big business here. New Britain became such a powerhouse that even through the Great Depression, its losses were minimal. Even with some closures and loss of jobs, New Britain took care of itself and was ready to convert and adapt to life during World War II.

After the war, when the manufacturers began feeling constrained by their limited space and were being wooed by communities with better land and transportation access, some tried to redevelop New Britain to retain these businesses. However, New Britain's great manufacturers found it increasingly difficult to compete while using outdated buildings and having limited highway access. In the end, many of the larger businesses left or were bought out by larger conglomerates, and the factory complexes sat empty.

A period of redevelopment ensued, largely characterized by new expressways cutting through town and demolishing factories to create commercial districts. Manufacturing was largely moved away from the constraints of downtown, where larger single-story buildings with better highway access could be built. At the same time, the realities of a new economy were setting in, challenging residents and leaders to maintain New Britain not as a depressed industrial wasteland but as a resilient and modern city that retains a bustling economy. Numerous efforts ensued to accomplish this, and these were met with varying degrees of success, district by district.

This period in some ways continues today, as New Britain seeks to develop its identity as a modern city. At the same time, the challenge of current leaders is to regain economic prosperity in what is a largely postindustrial city. Some areas, such as the Little Poland district, have been very successful. Other areas, however, have seen little change or growth in business, leaving buildings empty and crumbling. The downtown district is probably the best example of the current effort; with numerous projects in progress, time will tell if the heart of New Britain can regain the vibrant, cosmopolitan, and economic grandeur that it saw in the previous century.

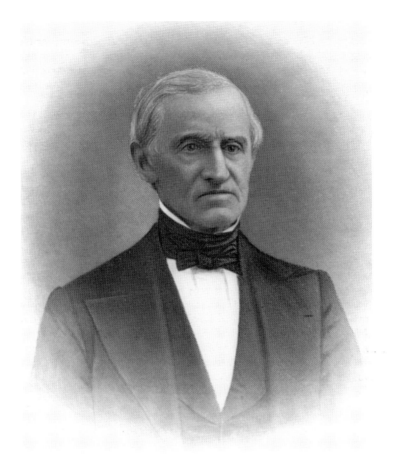

Frederick Trenck Stanley (1802–1883)

Grandson of Revolutionary War hero and prolific public servant Col. Gad Stanley, Frederick T. Stanley would hear a similar calling to public service and a revolution in industry. He began his career as a clerk, working for a time on the steamboat *Oliver Ellsworth* (the namesake of Reverend Smalley's student) between Hartford and New York. He worked as a Yankee peddler for a time and started a hardware partnership in North Carolina. In 1831, Stanley moved back to New Britain to begin a small hardware factory that did not survive the Panic of 1837. In 1842, he bought an abandoned building in New Britain with his brother William, and the next year, they opened Stanley's Bolt Manufactory. This was a significant undertaking because of their choice of power for their machinery. At this time, machine power was normally provided by the operator, flowing water, or horse treadmills, all of which were inefficient and unreliable. The Stanley brothers' operation was the first in town to make use of a one-cylinder, high-pressure steam engine. Manufacturing hardware items such as bolts, doorknobs, and handles, the company was incorporated 10 years later as the Stanley Works, for which Frederick served as active president until 1864. The Stanley Works merged with Stanley Rule & Lever in 1920 and would continue to operate under the Stanley Works name until 2010, and then under a partnership with Black & Decker to this day. Though methodical in business matters, Frederick Stanley was always energetic and progressive, and he was a constant presence in local political life. He was active in the incorporation of New Britain into a separate town in 1850. He was always abreast of the changing needs of the town and oversaw many great projects in New Britain, such as the city waterworks in 1857 with the reservoirs at Shuttle Meadow and Walnut Hill, respectively. In 1870, a city charter was obtained; at the first meeting of this new city, Stanley was elected mayor. Walnut Hill Park, considered to be the crown jewel of New Britain Parks and famously designed by Frederick Law Olmsted, owes its existence to the leadership of Stanley. (NBHS.)

J. Andrew Pickett (1829–1900)

Pickett came to New Britain in 1851 and began as an employee of Alvin North and his sons' factory. He and Loren F. Judd purchased a half-interest in the establishment, and this would become North & Judd Manufacturing. Pickett was active in local and state government and served as the city's sixth mayor. He took part in the development of New Britain's sewer system, a key step to cityhood. (NBHS.)

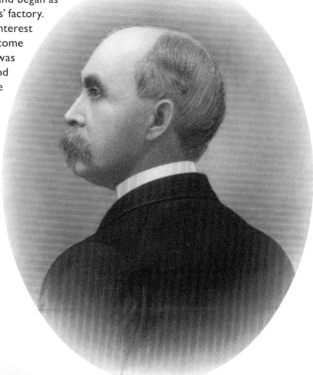

William H. Smith (1800–1873)

Smith was an industrialist and investor who, in 1829, partnered with Seth North and Henry Stanley to build a hardware factory at South Main and Pearl Streets. This shop was the first in New Britain to use coal in the foundry (rather than the less-efficient charcoal). Although his name is not well known, Smith was a key player in the early years of a number of great manufacturers, including Russell & Erwin. (NBHS.)

Charles E. Mitchell (1837–1911)
Mitchell came to New Britain to practice law, and in 1870, he and his partner, F.L. Hungerford, drew the original charter for the city. While performing numerous local and state civic duties, Mitchell specialized in patent law, becoming one of the foremost patent attorneys in the United States. Pres. Benjamin Harrison appointed him commissioner of patents in 1889. Drawn to New Britain to make a living, Mitchell became instrumental in the city's development. (NBHS.)

Rev. Constans L. Goodell, DD (1830–1886)
Goodell, born, raised, and educated in Vermont, was ordained and installed as the second pastor of New Britain's South Church in 1859. His first years were largely overshadowed by the Civil War. After the turmoil of the war subsided, Goodell began expanding South Church, both physically and in terms of membership. During the last nine of his 14 years as pastor, Rev. Goodell erected a new church edifice and doubled the congregation. (NBHS.)

Frederick Law Olmsted (1822–1903)
Olmsted, known as the "Father of American Landscape Architecture," was invited by Frederick Stanley to design a modern park at Walnut Hill in 1869. Although busy with New York's Central Park, Olmsted agreed and drew up plans for the park that included extensive walkways, fountains, and open spaces. While not all of his planned features were realized, the overall layout of the park today is essentially the same. (NBPL.)

R. Peter Ledger (1936–2011)
Ledger dedicated his life to parks and recreation, serving in local governments for various towns and even holding high positions on state and national parks and recreation associations. He was director of New Britain Parks and Recreation between 1984 and 2002. His leadership led to many improvements to the city's parks. A pathway, "Ledger's Way," and a memorial were created in his honor at the southeast corner of Walnut Hill Park. (NBHS.)

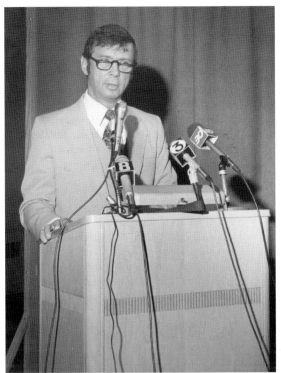

William J. McNamara (b. 1935)

"Bill Mac" McNamara served his city as mayor from 1977 to 1989, the most consecutive terms of any mayor. His terms spanned the last years of redevelopment, the dark years of the Probe, and development of the postindustrial economy. McNamara was the last mayor to oppose the state in expressway construction, calling a proposed section the "Highway to Nowhere." The state eventually abandoned the proposed section of Route 72 to Newington, as a result of outcry from residents of the affected towns. The Probe was a citywide investigation that uncovered corruption related to gambling and promotion exams, leading to 29 arrests, including that of the chief of police. McNamara worked hard to help his city's economy grow. Whether residents believed in his policies or not, most were delighted that Pres. Ronald Reagan planned a visit in 1987 to speak about economic growth. (Both, NBPL.)

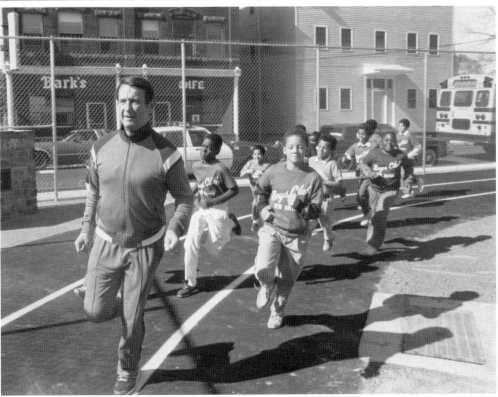

George A. Quigley (1880–1953)

Quigley's eight terms as mayor spanned the years 1914 to 1946. He led the city through the Depression and he devised a city welfare system. He would later oversee the conversion of the city to a wartime economy during World War II. Quigley, worried about a potato shortage, ordered increased production at the town farm and volunteered his own basement for storage. The shortage never occurred, and Quigley was stuck with the rotting potatoes. (NBPL.)

Paul J. Manafort (1923–2013)

A respected World War II veteran, Paul Manafort was a leader in numerous business, social, civic, religious, cultural, and political organizations. He served as mayor (1965–1971) and was secretary-treasurer of Manafort Brothers, Inc., a leading construction company begun by his family in 1946. He was honored in 1994 with the naming of a road running along the south side of CCSU, Paul J. Manafort Drive. (NBPL.)

David Nelson Camp (1820–1916)
Camp was a respected educator, author, mayor, and executive of several corporations. Like many of his peers at the time, Camp was a promoter of philanthropy, religion, and temperance: "Abstain from all intoxicants; have faith in God and man; live to make others happy and the world better." From 1850 to 1866, Camp was a teacher and principal of the first Normal School, which was on Main Street, across from South Church. (NBHS.)

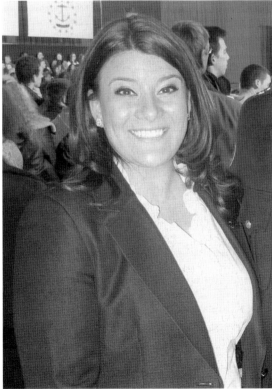

Erin Stewart (b. 1987)
Stewart was elected New Britain's 40th mayor in 2013, a decade after her father, Timothy Stewart, began his first term. A lifelong resident and the youngest mayor so far, Erin Stewart had already dedicated an impressive amount of service to the community. She served on the board of education, as a legislative aide for the state legislature, and as justice of the peace. In her first year in office, Stewart welcomed Pres. Barack Obama when he visited in May 2014. (NBHS.)

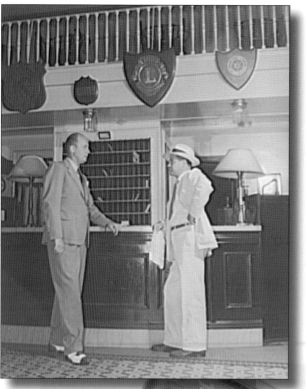

Burritt Hotel

Built in 1924 and named after Elihu Burritt, this was part of a 1920s drive to create a more modern and beautiful downtown. Manager Fred Lessing (pictured in white hat) helped maintain the hotel's image in the dark days of the Depression and into the 1940s. Lessing was a typical white-collar Connecticut man who enjoyed sailing when he was not mingling with his guests. Running a full-service hotel such as one would find in New York City, Lessing essentially created the social hub of downtown New Britain. Now a housing project, the building's imposing magnificence (below) still brings back fond memories. (Above, courtesy Library of Congress; below, John Phelan, under Creative Commons Attribution–Share Alike 3.0 Unported.)

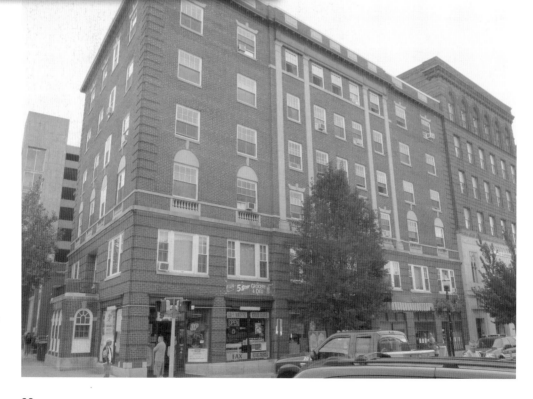

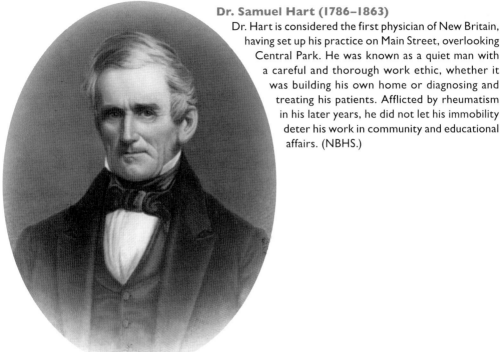

Dr. Samuel Hart (1786–1863)

Dr. Hart is considered the first physician of New Britain, having set up his practice on Main Street, overlooking Central Park. He was known as a quiet man with a careful and thorough work ethic, whether it was building his own home or diagnosing and treating his patients. Afflicted by rheumatism in his later years, he did not let his immobility deter his work in community and educational affairs. (NBHS.)

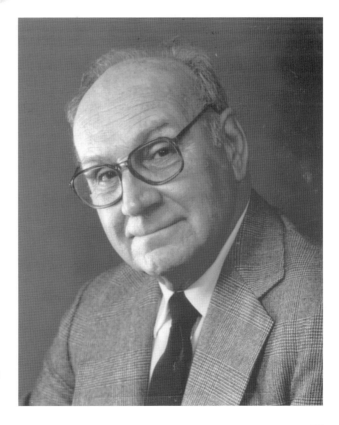

Dr. Granville Montgomery Winship (1919–2007)

In 1950, Monty Winship came to New Britain, where he pioneered and led the psychiatric departments at Grove Hill Medical Center and New Britain General Hospital for several decades. Dr. Winship dedicated himself to mental health for his community, establishing programs in the public schools and family assistance centers, as well as founding several mental health clinics in New Britain and surrounding towns. (Dr. Christopher Winship.)

Darius Miller (1829–1919)

In 1859, a Middletown farmer named Stephen Miller called his four sons together for a family meeting. Miller wanted them to have a chance to find their own callings, rather than remain farmers. He had saved up enough money to give each son $700—sufficient, perhaps, for them to start a new life. As it turned out, the four sons—Charles, Darius, Frank, and Nathan—used their seed money and work ethic to do very well. Indeed, all four boys grew up to become among the richest men in the state, and at times were the richest men in their hometowns. Nathan made his fortune on Wall Street and as an executive of steamboat, railroad, and electric companies. Frank became president of a lumber company and a bank in Bridgeport, Connecticut. Charles moved to Waterbury, where he ran the city's dry-goods industries. Darius Miller came to New Britain, started a dry-goods store, and lived most of his life in a meager apartment above that store, leading a very frugal and humble life with his wife, Lizzie. While Darius and Lizzie (pictured) pinched every penny and appeared to be struggling shop owners, Darius's bank accounts grew steadily from his investments in large financial institutions. Darius knew he had more money than he could ever spend, yet he could not bring himself to live as such. He finally agreed to build a house, at his wife's urging, but he would not hear of moving out of their more economical apartment. A director of New Britain National Bank, he was known as a shrewd businessman with an insistence on the details of every transaction. He was also known at the teller windows for his insistence on using scraps of paper for checks, rather than allow his bank to squander money on printed checks. Upon his death, Darius's wealth totaled nearly $3 million, which broke down to $2.5 million in stocks and bonds, $75,000 in real estate, and $500 in cash and personal effects. The surprise to the city's residents increased when his will indicated that he donated most of this money to the hospital, the parks, the library, and other community institutions. Lizzie received $500,000 and was finally able to enjoy her wealth for a few years, unlike poor Darius. His name is memorialized in the Darius Miller Band Shell at Walnut Hill Park. (NBPL.)

New Britain Children's Humane Society
The Children's Humane Society was formed to prevent the suffering of working animals and strays in the city. Around 1900, the society devised this basin for thirsty horses and dogs, collecting pennies until it finally had enough to build and install it. Unfortunately, the trough was too low for horses and too high for most dogs. Nobody had the heart to tell the society's members, so it has remained at that height, serving as a seasonal planter. (NBHS.)

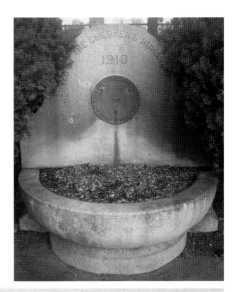

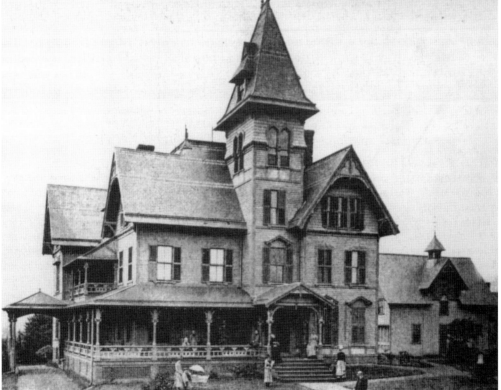

New Britain General Hospital
New Britain General Hospital housed 34 Spanish-American War soldiers with typhoid fever for several months before the hospital was open to the public. In a timely coincidence, the first building had been acquired two years prior and required funds to convert the Victorian home to a hospital. This arrangement allowed the soldiers to convalesce close to home, and the publicity helped the hospital raise the funds to open its doors. (NBPL.)

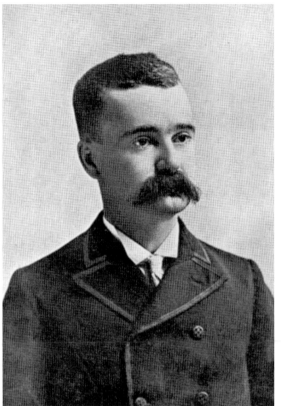

Robert J. Vance (1854–1902)
Vance started the *New Britain Observer* in 1876, and he served as president of the Herald Publishing Company, which consolidated the *Herald* and *Observer* in 1887. He served as city clerk (1878–1886) until he was elected to the state general assembly, and then to the US Congress in 1887. After serving in national politics for a time, Vance came back to New Britain to serve as mayor in 1896. (NBHS.)

Ethan Allen Andrews (1787–1858)
Andrews began his career as a lawyer, but his passion was for education. An expert in Latin, he was a professor at the University of North Carolina and at Yale. He created some private schools, including the successful New Haven Young Ladies' Institute. Andrews is known for his Latin texts, especially the *Latin-English Lexicon*. He was also instrumental in the establishment of the first Normal School and High School in New Britain. (NBHS.)

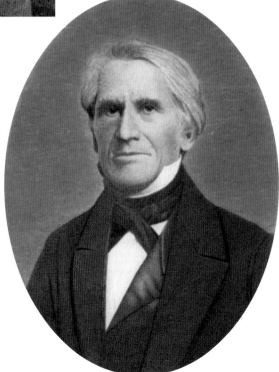

CHAPTER THREE

Artists and Entertainers

One can hardly travel through the streets of central New Britain without seeing the influence of the arts and how this city embraced them. Theaters, museums, outdoor sculptures, and murals are prominent in the downtown area, as are advertisements and signs giving evidence to arts and entertainment throughout the city. A variety of landmark organizations, artists, entertainers, and those devoted to promoting the arts can be found throughout the history of the city.

Early New Britain residents, although hardworking and devout Puritans, understood the value of entertainment. There were limits to what the church (as well as Puritan morality) would allow, but youngsters pushed these limits, as they do today. Many of the traditional modes of entertainment served more than one purpose, and may resemble religious functions or community work projects by today's standards. Some of these activities included sewing or quilting circles, barn raising, church picnics, or merely reading the available texts of the society library. Younger folk, much to the chagrin of the church pastor, looked to the taverns for entertainment, singing and dancing well into the evenings when they could.

Around the turn of the 20th century, New Britain began attracting and nurturing artists and entertainers among local residents as well as newcomers. This includes a list of local residents who have excelled in some form of art or entertainment, as well as accomplished persons who came to call New Britain home. While many such artists and performers made a living through sales, New Britain pioneered the creation of organizations to support the arts.

The New Britain Museum of American Art (NBMAA), for example, was founded in 1903 as not only the first museum strictly for American art, but also for providing services in art education, cataloging, and conservation. The success of the NBMAA is at least partly attributed to the appointment of artists to direct it in its formative years. Artists like Sanford B.D. Low had a more intuitive and functional understanding of the art business and knew where to find up-and-coming American works of art. This museum, a prominent and celebrated institution, attracts artists and art lovers from around the world.

Another pioneering organization, the Art League of New Britain (ALNB), is the second such institution in the United States. Originally started as an art school in 1928 under the leadership of Sanford Low, it became a social and support organization for artists beginning in 1934. The ALNB is also credited with saving and preserving its home, a 19th-century carriage house and stable. And, like the NBMAA, the ALNB has the reputation of bringing together people from all over the city to appreciate the arts and artists of New Britain.

In 1994, leaders from the NBMAA, the Youth Museum, and the public library, as well as other members of the arts and cultural community, began taking stock of all of the city's cultural resources. They then created a nonprofit group, the Greater New Britain Arts Alliance (GNBAA), which created a large source of funding and advocacy for artists, performers, and smaller organizations in New Britain and neighboring towns. The GNBAA has since been very successful in promoting arts on the local, state, and national levels. This has not only helped keep arts and culture alive in New Britain, but has also improved the image of the city as a cultural hub.

Finally, the City of New Britain has also become involved in promoting the arts through a formal body. The New Britain Arts Commission keeps abreast of events and trends related to the arts in the city; administers a visual art exhibit in City Hall for the work of local artists; and works on programs for public arts. Besides the City Hall exhibit, this commission is instrumental in the initiation and administration of public arts, such as outdoor murals and sculptures.

Whether influenced by or involved with these organizations, the artists and entertainers that became celebrated in New Britain and beyond have always been an important part of the heritage of this city. Moreover, it can be said that just as the great industrialists of New Britain triumphed through innovation and excellence, so the people included in this chapter excelled in their individual form of art or entertainment.

Dexter William Fellows (1871–1937)

Fellows grew up in Fitchburg, a quaint suburb of Boston, the middle child in a working-class family. He acquired his first employment at age 14 as a paperboy. A summer entertainment highlight of the era were traveling shows, such as Barnum & Bailey's and Buffalo Bill's Wild West. Fellows sought out the press agents, offering to work in exchange for free passes. His enthusiasm earned him a job as a press agent himself, working for Pawnee Bill's Historic Wild West Show. He later worked for Buffalo Bill, Ringling Brothers, and Barnum & Bailey. These jobs took Fellows all over the country and even the world.

Press agents for circuses were notorious among reporters for falsehoods and embellishments. Fellows, however, had a way of charming them with small talk about their locality, well-placed humor, and a truly fascinating way of delivering his fanciful claims. He would leave his audience with a sense of wonder and enthusiasm, as well as great material for their newspapers. Hartford was a regular stop, and the press would flock to hear the tales of Fellows, considering him a dear friend.

Fellows often announced himself as "Dr. Fellows of the Royal Hyperbolic Society," "Colonel Fellows of the Northwest Mounted," the "Reincarnation of Munchausen," and, finally, the "owner of an adjective factory in New Britain." If one could believe the newspapers, it was he who scoured the jungles of Burma and Siam, searching for white elephants; crossed Australia in the pouch of a kangaroo; helped Noah drive the animals into the ark; taught the Ubangi ladies to play tiddlywinks on their lips; and followed the edge of the Gulf Stream in a rowboat to determine the exact beginning of spring. The last of the great tellers of tall tales, Fellows knew Sitting Bull and Annie Oakley and recited stories of the Overland Trail, the Pony Express, and Indian warfare—elements that were so prominent in the Great American West.

He married a young woman of nobility from Sweden, Signe Eugene Von Breitholtz, and they settled in New Britain. After spending the winter months here, Fellows and his wife would join the circus every March when it opened in Madison Square Garden. Fellows died while traveling with his beloved circus, and he was buried with great honors in New Britain. Today, one still hears the phrase that is credited to him: "The Greatest Show on Earth." (NBHS.)

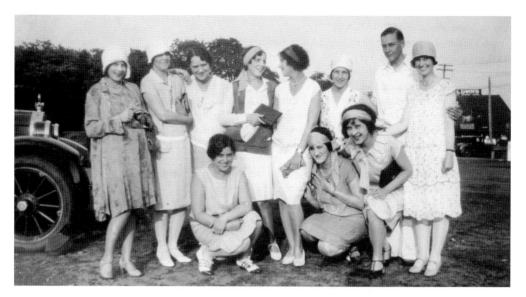

New Britain Normal School Glee Club
These young students were popular representatives of the Normal School in the Roaring Twenties and early Depression years. This was an all-female group, selected from the school choir, who sang traditional and popular songs. They were seen and heard around the state, on the radio, and, of course, in downtown New Britain. As pictured here, the glee club occasionally brought in guests, such as violinist Fritz Heim. (NBHS.)

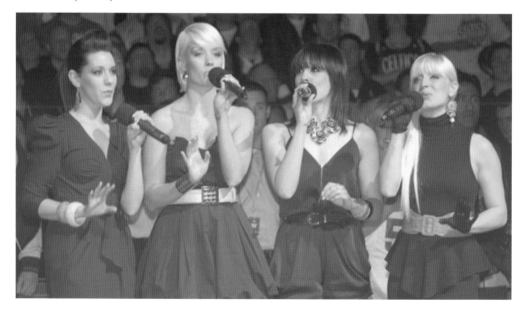

April Forrest and Jada
Born and raised in New Britain, Forrest was a natural dancer who began lessons at age two. She attended New Britain High and Greater Hartford Academy of the Arts, becoming an accomplished singer, dancer, and choreographer. Forrest then joined Boston's rhythm & blues and pop band Jada. The band, including Forrest (far left), are shown here singing at a Boston Celtics game. An accomplished and respected artist, she now teaches others at the very studios that launched her own career. (NBHS.).

Theodore Wilson (1912–1986)

Teddy Wilson was born in 1912 and raised in the South. While attending Tuskegee College, he discovered a gift for piano and became very adept in classical music. His first piano instructor also taught him the art of jazz music, and, after a visit to the jazz scene in Detroit, Wilson doubled his efforts and became a great player of both classical and jazz, blending the two in a unique interpretation of the early swing style of the 1920s. Wilson left home for Detroit with $50 in his pocket and soon found himself playing clubs with popular bands in the Midwest and across the country. By the 1930s, Wilson was playing with Louis Armstrong at Al Capone's Gold Coast Club and other speakeasies. This was lucrative, but Wilson was drawn to Harlem in 1935, where he teamed up with Billie Holliday. The duo began creating recording bands under names like Teddy Wilson and His Orchestra, utilizing talent such as Benny Carter, Johnny Hodges, Benny Goodman, and Ella Fitzgerald. More importantly, Benny Goodman invited Wilson to join his orchestra, thus becoming the first white band to integrate. Wilson's lively and melodic style helped define Goodman's music in the late 1930s, during which Goodman was dubbed "King of Swing." Touring the country with Goodman's band (seen here), Wilson often faced awkward and humiliating situations brought on by Jim Crow laws. He played for the next few decades with Goodman and other bands, and was travelling all over the world by the 1950s. He and Goodman were even invited to the Soviet Union to play in front of Kennedy and Khrushchev in a "cultural exchange" program. By the 1980s, Wilson had separated from his fourth wife and was playing clubs with two of his sons, mainly in the Northeast. He eventually met and moved in with a woman in New Britain, making his home base at a restaurant on Gold Street in Hartford. He spent his last years playing from New York to Boston, but he increasingly stayed closer to home, playing mainly at restaurants in Hartford and Farmington. Teddy Wilson died in his home in New Britain on July 31, 1986, less than two months after his old friend Benny Goodman passed. The "Mozart of Jazz," who called New Britain home for his last years, is often celebrated here as an inspiring musician and role model. (Library of Congress.)

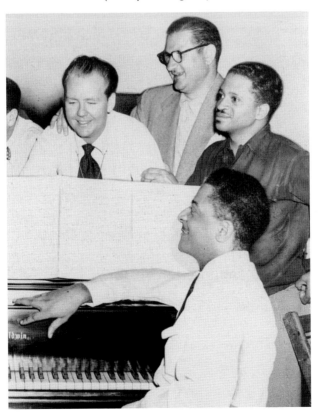

David LaFlamme (b. 1941)

LaFlamme (front, center) was born in New Britain in 1941. His mother was a Mormon, and he was raised in Utah, where he became an accomplished violinist in the Utah Symphony. He moved to San Francisco in 1962, playing with the likes of Jerry Garcia and Janis Joplin. In 1967, he joined the band It's a Beautiful Day, which recorded the hit song "White Bird." LaFlamme contributed violin, flute, and vocals on several albums before the band broke up. He continued making music on his own, played with various bands before creating the David LaFlamme Band (pictured), which continues to this day. (David LaFlamme Band.)

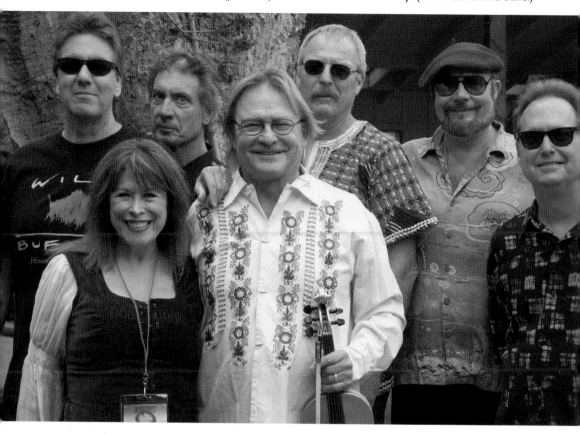

Meta Grimm-Lacey (1888–1976)

Meta Grimm was born in Wisconsin in 1888. She married traveling salesman Mark J. Lacey, retaining her maiden name in honor of her ancestors, the Brothers Grimm. In 1929, she moved to New Britain and was a painter of flowers, homes, and local scenes. Her work, described as realistic yet ethereal, is still very much in demand today. She was a member of the New Britain Museum of American Art as well as the New Britain and Hartford Art Leagues. Artists may remember seeing her during the annual New Britain Sidewalk Exhibitions outside the museum. Children would probably remember her as well, for her wonderful home. Grimm-Lacey adorned her home with furnishings, decorations, and artwork as a tribute to the Brothers Grimm fairy tales. Meta Grimm-Lacey died at the age of 88 at New Britain General Hospital. (NBPL.)

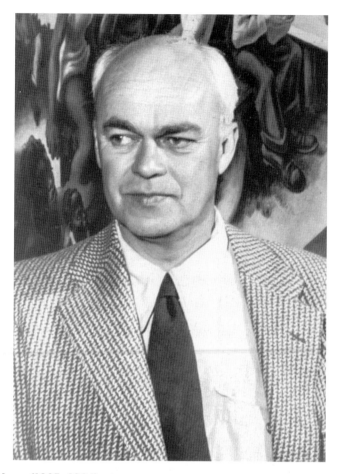

Sanford B.D. Low (1905–1964)

Sanford Ballard Dole Low was born to a rancher named Rawhide Ben Low, one of Hawaii's most famous cowboys. His lineage can be traced back to King Kamehameha the First, who had unified the Hawaiian Islands. Sanford's parents sent him to a boarding school in Windsor, Connecticut, to obtain a high school education outside Hawaii. Sanford aspired to be an artist, and he decided to attend the Museum School in Boston, where he not only developed his artistic talents but also organized the school's first and only football team. After graduation, Low moved to New York, where he studied at the Grand Central School of Art and the Art Student League. He spent four years there as a commercial artist until meeting his future wife, Virginia Hart. Her parents, a wealthy New Britain Hart family, eventually approved of her marrying a poor artist after he won them over with his irresistible personality. After their marriage, Low moved to New Britain, where he began exhibiting his art and soon opened the art school that became The Art League of New Britain. At the end of the 1930s, Low was asked to be on the board of directors of the new Museum of American Art. While not the usual position for an artist, the board knew of his ability to find great art that was either unfashionable or funded by the Works Progress Administration, and thus affordable. Familiar with the industry, Sanford Low became known for swooping in to acquire paintings before they became available to the public. He even acquired five Thomas Hart Benton murals from the Whitney Museum in New York for pennies on the dollar, personally supervising their quick removal and getaway in what was described as a "caper." While a legal transaction, the haste was probably out of concern that the Whitney directors would come to their senses and stop the sale. The Benton murals became one of the many great works Sanford Low helped the museum acquire, making it one of the most respected American art museums. (NBPL.)

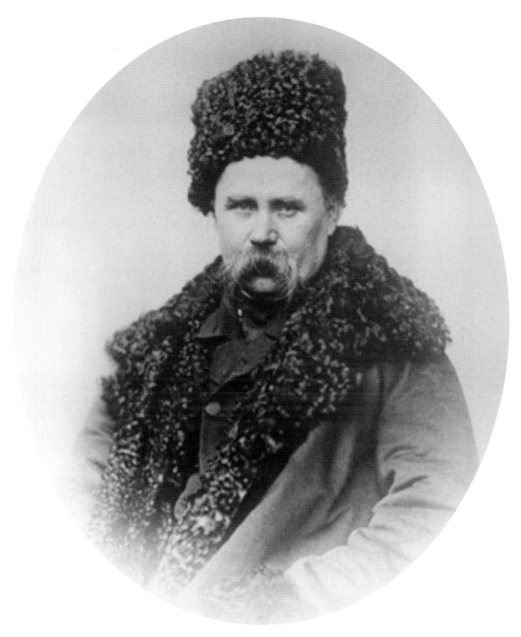

Taras Shevchenko (1814–1861)
Taras Hryhorovych Shevchenko, an accomplished poet, writer, and artist, was celebrated for his contribution to Ukrainian culture and for his critique of Russian imperialism. Shevchenko was sent into exile after writing a poem, "The Dream," which criticized the tsar and his wife. After about 10 years at a harsh military post, he began working on his art again, but he died after a difficult illness at the age of 47. Starting in 1889, Ukrainians began immigrating to New Britain to seek freedom and opportunity. The Ukrainian community has become a vibrant and visible part of the city, and the annual Ukrainian festival honors Shevchenko through his plays, poetry, and song lyrics. A section of Route 9 in New Britain is designated the Taras Shevchenko Expressway, publicly memorializing the national hero and honoring the city's Ukrainian heritage. (Taras Shevchenko National Museum of Kiev.)

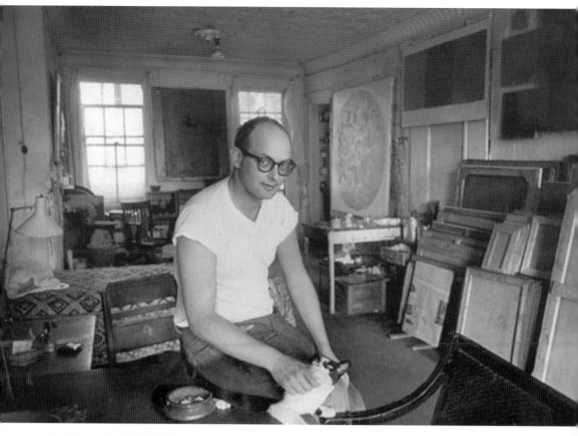

Sol LeWitt (1928–2007)

A son of Jewish immigrants from Russia, LeWitt was raised in New Britain from age six by his widowed mother. He developed an affinity for art by taking classes at the New Britain Museum of American Art and at Hartford's Wadsworth Atheneum, earning a BFA from Syracuse University. He then traveled in Europe to study Old Master painting. LeWitt spent several years in New York City, developed his abilities in graphic design and later teaching at local schools. He lived in Italy during the 1980s, then returned to Connecticut to spend his remaining years. He achieved much acclaim for his wall drawings, "structures," prints, photography, and painting. LeWitt is linked especially to the Conceptual and Minimalism art movements. In 2012, New Britain honored Sol LeWitt by reproducing one of his wall drawings on a downtown building. (NBPL.)

Jim Aparo (1932–2005)

James N. Aparo was born in New Britain and became a renowned comic-book artist, especially for his work with DC Comics. His first job in the industry was a 1963 strip in the *Hartford Times,* called "Stern Wheeler." Working out of his studio in the neighboring town of Southington, he then worked for DC Comics, illustrating the Aquaman series, then several Batman series until a year before his death. (Michael Netzer, Creative Commons Attribution–Share Alike 3.0 Unported license.)

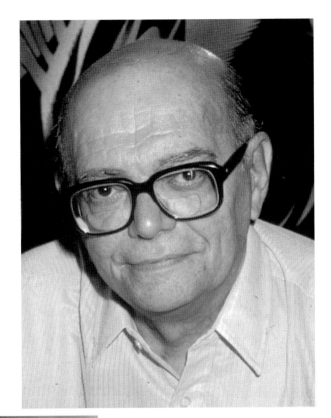

Vince O'Brien (1919–2010)

O'Brien, raised in New Britain, began acting in the 1950s. He played authority figures in television programs such as *Westinghouse Studio One, Dark Shadows, Ryan's Hope,* and *Law & Order.* He played the "Shell Answer Man" in commercials in the 1960s and 1970s. O'Brien's film appearances include *Annie Hall, Quiz Show,* and *Six Degrees of Separation.* His son has carried on his work, as a director for *All My Children* and *The Young and the Restless.* (NBPL.)

47

Velvet Sky

New Britain–born Jamie Lynn Szantyr was a cheerleader and athlete in high school, then soon after decided to become a professional wrestler. She made her debut in 2004, and her athleticism, charisma, beauty, and talent has made her a favorite in the world of sports entertainment in both the United States and Mexico. Fans are drawn to her abilities both in directly engaging her audience and in performing as a dynamic athlete. (© Glenn Francis, www.PacificProDigital.com. GNU Free Documentation License, Version 1.2.)

Penny Arcade

The daughter of a New Britain immigrant Italian family, Susana Carmen Ventura left home at age 14 to join the underground theater. At age 17, she renamed herself "Penny Arcade" and for a time worked for Andy Warhol. She then worked with underground and traditional music and theater groups in Amsterdam and Spain. She now works in New York City, promoting free expression, feminism, history, social studies, art, and culture. (NBHS.)

CHAPTER FOUR

Industria Implet Alveare et Melle Fruitur

The Latin phrase that forms the title of this chapter, devised by Elihu Burritt as New Britain's motto, is included on the seal, along with a depiction of a busy beehive. The phrase's English translation, "Industry Fills the Hive and Enjoys the Honey," is the title of this chapter because it essentially describes how the legendary industrialists lived. The 19th-century capitalists and industrialists were celebrated not only because they built the great factories and grew a small town into a bustling city, but also because the fruits of their labor were evident throughout the city. These men, who might be seen making a spectacle of themselves with their fine clothes and entourages, erected beautiful mansions downtown and left their legacies through institutions and monuments. In addition, the city's motto brings forth the social conditions of the industrial revolution and Gilded Age, the fact that capitalists grew extremely rich while the working class barely survived.

Thus, perhaps the first local legend worth mentioning in this chapter is the factory worker of New Britain. These were the men, women, and children who worked in pioneering industries, often with unproven and unsafe methods and conditions, turning out beautiful hardware, state-of-the-art machinery, or modern appliances. Whether working to meet market-driven schedules or to support the war effort, the New Britain factory workers, many of who came here from afar, knew that their efforts were proudly celebrated by the city. For while these were the people who made the honey for industry to enjoy, they were and always will be considered essential to the success of the factories and the rise to greatness of the Hardware City.

The industrialists of New Britain had characteristics that set them apart not only from their modern counterparts, but also from their contemporaries. The foremost argument for this is the fact that industrialists chose to build their factories in New Britain despite not having access to water for transportation. Before railroads and steam engines were proven factory power sources, New England's factory towns sprang up near rivers and tributaries. The brooks that ran through some parts of New Britain had long before been claimed by sawmills and gristmills. The stream that ran across Main Street was usually too slow to be of much use. Powering a factory meant using operator-power, horse treadmills, or modifying an available stream. However, after Frederick T. Stanley, in 1843, proved the usefulness of the steam engine and established a reliable trade route for coal, production in New Britain exploded in both output and diversity. With this, industrialists focused on creating truly innovative product lines that supplemented the already extraordinary levels of production with truly world-class products.

Thus, the legendary industrialists of New Britain were pioneers in innovation in terms of both factory technologies and products. Not only did these men become successful manufacturers in their field, but they also collectively influenced the creation of an industrial and cosmopolitan city from what was once a sleepy village. So, to this day, despite for the most part being long gone, the great industries of Hardware City are celebrated. Some will argue that many of the great manufacturers abandoned New Britain in search of better profits, and that there is much more to the city than manufacturing. Nevertheless, it is

a fact that New Britain would never have become the great, prosperous, diverse, and bustling city that it has without the efforts of its legendary industrialists.

Traditionally, there are a few manufacturers mentioned in history books as the definitive firms of this city. This begins with North & Shipman's brass goods factory, which many consider the birth of New Britain's industrial era. Stanley Works and Stanley Rule & Lever were pioneers in builders' hardware and tools, and they later merged to form the Stanley brand known today. North & Judd was a manufacturing giant that produced everything from equestrian and upholstery hardware to electrical fittings. Union Manufacturing was a leading producer of industrial tools. Russell & Erwin Manufacturing and P&F Corbin produced decorative and security cabinet and door hardware. Fafnir Bearing was a leading producer of ball bearings for all types of vehicles and equipment. Landers, Frary & Clark produced a large array of kitchen utensils and home appliances of all sizes under the brand Universal. American Hosiery and New Britain Knitting were pioneering producers of modern undergarments. Finally, New Britain Machine produced hand tools and manufacturing equipment that can be found in machine shops and garages decades after the company stopped producing.

Additionally, companies that were begun more recently are legendary in their product lines. These, to name but a few, represent New Britain's current diversified industrial base that includes everything from electronics to food and beverage products. Corbin Motor Vehicle was P&F Corbin's venture into the exciting and competitive world of automotive manufacturing. Cremo Brewing created a beer that was popular in restaurants and taverns alike. Peter Paul Electronics has been very successful in building electric valves that are widely used in a variety of industries. Martin Rosol Company is renowned for its sausage products, which can be found in restaurants and supermarkets in the greater New Britain area. Avery's Beverages has been bottling soft drinks and delivering them to businesses and residences for 110 years. American Electric supplied many of the first sources of electricity and electric lighting to New Britain; the company went on to become General Electric. Spring Brook Ice & Fuel recalls the bygone days of ice harvesting on New Britain's ponds. The New Britain Gas Light Company merged with Hartford Gas Company to become a leading supplier in the state, Connecticut Natural Gas. Certainly, these companies were not all as influential in the development of the city as those previously mentioned. Yet, these are examples of companies that produced remarkable products or served the residents of New Britain.

So, whether one finds fascinating the innovation of industrial development, production methods, or products, New Britain has long been the home of many legendary industrialists and companies. Long after most large manufacturers left the city in its postindustrial age, residents still speak with fondness and respect of the men and their factories that created Hardware City.

Seth J. North (1779–1851) and Lorin F. Judd (1820–1896)

By the 1830s, Seth J. North (left) had become an expert in making brass and plated hardware items. He set up a saddlery and produced tack hardware along with his brother Alvin and Alvin's sons Hubert F. and Oliver B. This was one of several ventures that Seth North would lead or help, earning him the title of "Father of New Britain Industry." By 1863, only Hubert F. North remained in this saddlery hardware operation, partnering with Lorin F. Judd (right), a member of the family that owned the nearby sawmill. This heralded North & Judd Manufacturing, which soon after became the Anchor Brand, for which it was well known. North & Judd remained as one of New Britain's largest manufacturers until it moved its operations to Westfield in the early 1970s. (Left, NBHS; right, NBPL.)

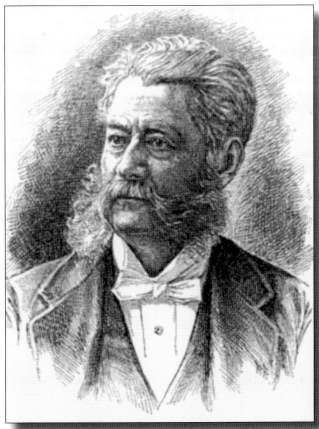

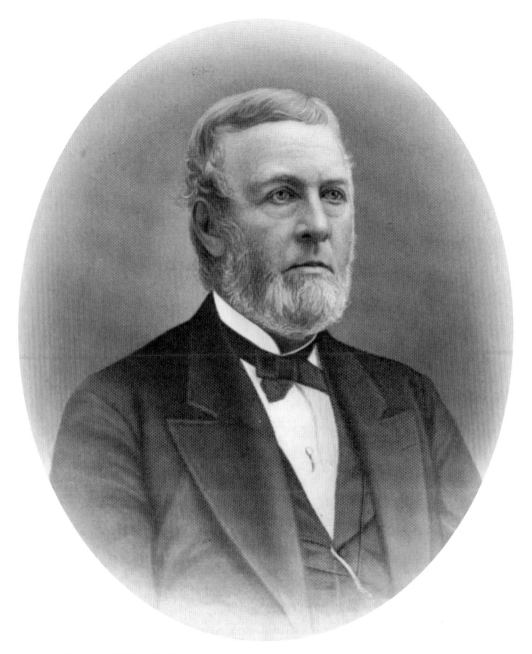

Henry Stanley (1807–1884)

Cousin of F.T. Stanley and often overshadowed in the history books, Henry Stanley is one of the unsung heroes of New Britain's industrial past. Although he started a career in medicine with Samuel Hart, his family convinced him to enter the manufacturing business. He was an executive at American Hosiery, New Britain Knitting, Stanley Rule & Lever, and Stanley Works. Henry Stanley was a founding member of New Britain Knitting and Stanley Rule & Lever. He was greatly valued on the boards of local businesses for his intelligent and conservative judgment. Henry's son Theodore Stanley, a lieutenant in the 14th Connecticut Volunteer Infantry in the Civil War, died after bravely leading his unit in the Battle of Fredericksburg. (NBPL.)

Philip Corbin (1824–1910)
Philip Corbin (left) learned the door hardware business in 1844 while working for the Matteson, Russell & Erwin Company. He used these skills to form a partnership with his brother Frank in 1851, when they started a hardware business. P&F Corbin is known to this day for its decorative hardware and robust locks. Philip was involved in many other businesses, most notably Corbin Motor Vehicles. Corbin built his home (below) across the street from his factory. A fine example of the stately homes built by industrialists in central New Britain, this residence was located such that Corbin could always be near his business. Unfortunately, he had to demolish his home to make way for expanding facilities in the 1880s. (Both, NBHS.)

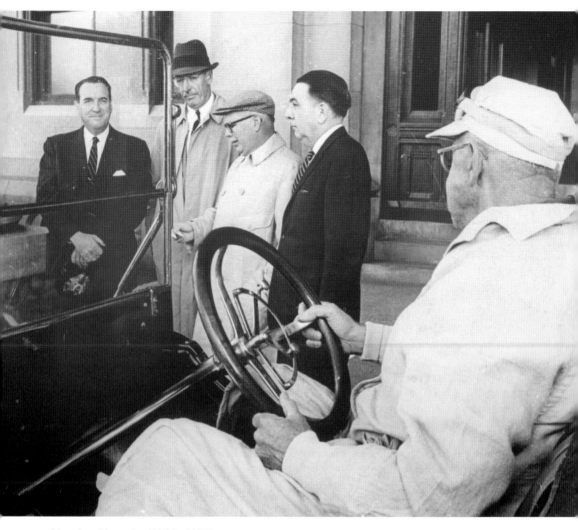

Charles Merwin (1880–1971)

Philip Corbin began producing automobiles in 1904, convincing his company, the Corbin Motor Vehicle Corporation, that he could create the "Detroit of the East." Indeed, he had the know-how, the facilities, and the vision to create a very nice car. Corbin utilized a showroom at Madison Square Garden to sell to upscale clients. He blended conservative reliability with the latest styles. Corbin promoted the cars for their speed and endurance by testing them in races alongside larger companies' cars. This is where Merwin (seen here in the driver's seat) came in; not only was he a salesman, but he also served as the test driver. While Corbin cars were probably among the best one could buy at the time, sales were never sufficient to keep the firm in business. Philip Corbin's dream was never realized, and the operation closed two years after his death. (NBPL.)

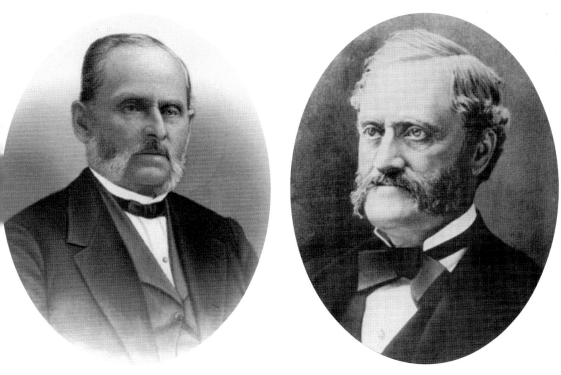

Henry E. Russell (1819–1881) and Cornelius B. Erwin (1811–1885)
Russell & Erwin represent one of the oldest and largest ventures of New Britain industry. This began in what was known as the Lock Shop, a factory that utilized waterpower from what would become known as the Lock Shop Pond. The company barely survived the Panic of 1837, and many of the original proprietors left in 1838. Cornelius B. Erwin (right), who had moved here from New York, had worked in New Britain just long enough to earn the money and reputation to invest in the Lock Shop in 1839. He joined the son of an original owner, Henry E. Russell (left), and the two by 1850 controlled this and several other hardware factories, subsequently creating the Russell & Erwin Manufacturing Company. Eventually, this and Corbin's company would combine as the Corbin Russwin door hardware manufacturer in nearby Berlin. (Left, courtesy NBPL; right, courtesy NBHS.)

George Marcellus Landers Sr. (1813–1895)
Born in Lenox, Massachusetts, George Landers came to New Britain about 1830 to work as a carpenter. Although he built his and other homes here, he was drawn to the profits he saw in local manufacturing. He started a small shop on East Main Street and built up what would be known as Landers, Frary & Clark. This company produced the Universal brand of housewares and appliances. (NBHS.)

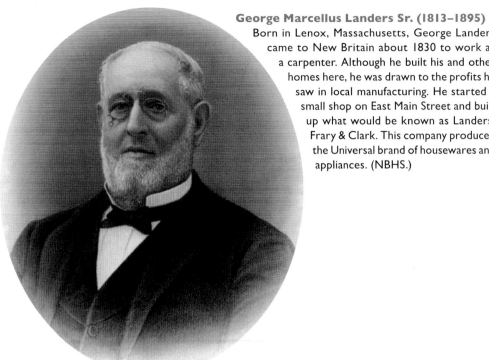

George Marcellus Landers Jr. (1870–1927)
Grandson of George M. Landers Sr., George Jr. worked as an executive at Landers, Frary & Clark after his father died. He was also a grandson of Loren F. Judd and served as president of North & Judd for a time. He served as mayor as both a Democrat and a Republican, and he was later a state senator. Landers had a promising political career, but he died unexpectedly at age 56. (NBHS.)

Charles Glover (1847–1922)

Charles Glover's father was a mechanic who brought his family to America when Charles was two years old, settling in the town of Enfield, Connecticut. At a young age, Charles showed a marked preference and skill for mechanics, as well as a diligence in his work. So much so that his father decided to hire him out to a farm at the age of 10 rather than bother with schooling. When his brothers went off to fight in the Civil War, his father brought Charles home to help in his machine shop. Charles set about learning the machinist's trade thoroughly and employed his evenings in study, for he was only too eager to supplement his meager education, which, during his labors on the farm, had been restricted to the winter season. Perhaps because of his interests, Charles focused his studies on applied mechanics. After the war, Charles began working for other companies as a machinist, and in 1876, he came to New Britain and was hired by P&F Corbin to assist with the development of its new screw-manufacturing department. He was put in charge of this department and designed all the screw machines employed in the new plant. In the 1903 formation of the Corbin Screw Corporation, Glover was elected president. By this time, Glover had become renowned for his ability to apply his understanding of the manufacturing business as an executive, and by 1908, he was appointed to positions such as president, vice president, director, and treasurer to more than a dozen companies in New Britain and beyond. Elihu Burritt has been called the "Learned Blacksmith" for his having educated himself when he was not working the forge. Although Charles Glover became an engineer and business executive and not an intellectual and statesman like Burritt, the basic means and objectives of their education were similar. Thus, Charles Glover can be remembered as the "Learned Machinist." (NBHS.)

Fafnir Bearing
Beginning in 1911 by Elisha Cooper, Fafnir Bearing grew quickly in World War I and World War II as one of the nation's foremost bearing producers. Fafnir had over 1,200 women in its employ by 1942 to replace the men who were serving overseas. Fafnir was the largest employer here, and employees were proud and fervent not only on the production floor, but also on the baseball fields and in the picket lines. (Library of Congress.)

John B. Talcott (1824–1905)
Talcott was a lawyer and teacher when he was invited by Seth North to partner in his manufacturing ventures. Talcott became president of the New Britain Knitting Company and then helped start American Hosiery, importing expensive machinery from England to make fine-grade undergarments. Legend has it that Talcott went to the manufacturer and talked somebody out of the plans, so that he could have the machines built in New Britain. (NBHS.)

Jonathon Draper and American Hosiery

Arriving here at the end of the 19th century, Draper began working for American Hosiery as a window washer. By 1907, he was not only foreman of the large undergarment maker, but an executive of the Foreman's Club. The Drapers were very active and well-liked around town, spearheading the social rise of the middle class in the churches, social halls, and other areas previously dominated by the rich industrialist families. (NBHS.)

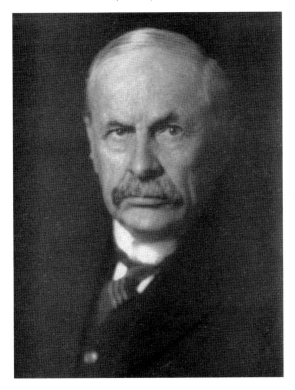

Andrew Jackson Sloper (1849–1933)

After high school, A.J. Sloper worked several odd jobs to survive, eventually becoming cashier at New Britain National Bank. He was president of that bank within 10 years and was soon on the boards of nearly every major business in the city. He expressed great concern about the new generation of businessmen, and legend has it that he quietly predicted the crash of 1929, making preparations that saved his investments. (NBHS.)

Justus A. Traut (1839–1908)

Born in Germany, Traut immigrated after high school to work at Stanley Rule & Lever. A brilliant designer, he created countless tools sold by Stanley, as well as devices to create its products. He also worked at other manufacturers and even created a major suspender hardware factory. He received over 700 patents, earning the title "Patent King" and contributing much to the reputation of New Britain as the hardware capital. (NBHS.)

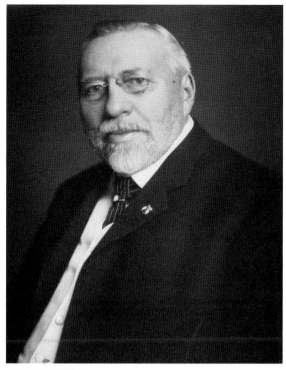

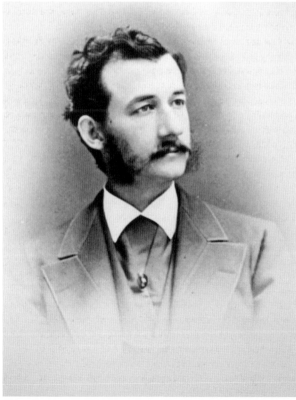

Frederick H. Churchill (1848–1881)

One of the more interesting and tragic figures of New Britain, Churchill partnered with electrician Elihu Thomson to create the American Electric Company. Their arc lamps were used in the 1880s by Corbin and other customers around the nation. Unfortunately, Churchill ran into cash problems early on and shot himself before his dream was fully realized. Thomson continued the company and eventually merged it into the formation of General Electric. (NBPL.)

CHAPTER FIVE

Immigration and Diversity

Although, in many ways, the immigrant story of New Britain resembles that of other New England towns and cities, it has had a number of distinctions over the years in relation to diversity that set it apart in the region.

During its first few decades, the population was completely homogenous, of English stock, with perhaps a few people of Irish or Scottish origin. Racial diversity could be seen with an occasional Native American or African American, although these people generally suffered economic suppression, relocation, and slavery. The Mattabesetts occasionally visited the area on hunting and gathering parties, but as farmlands displaced wildlife, their visits dwindled. Eventually, their local villages in Farmington, Wethersfield, and Middletown declined with disease and mass departures of Indians to join larger tribes to the west. A 19th-century researcher lamented the extinction in his book on Connecticut tribes: "So sleep, the Tunxis. So in time, perhaps will sleep the race which has succeeded them."

Early African Americans were largely kept as servants in the homes and barns of wealthy families. Although New England did not experience slavery as the extensive economic institution it became in the Southern colonies, a major port of entry for slaves was located in Providence, Rhode Island. The extent to which New Britain residents agreed with slavery is difficult to determine, as there are no writings discussing this. It has been surmised that, by the second generation, slavery was largely abandoned. Early state laws made it difficult to free slaves, as the previous owner would be held responsible for their welfare in cases of destitution, illness, or injury. Records of slaves were very limited beyond probate records, probably in response to the state law. Thus, while second-generation residents occasionally inherited slaves, local records provide little to no evidence as to what became of the slaves owned by the first settlers of New Britain. Beyond this, there is physical and literary evidence that, beginning in the early 19th century, some residents became agents of the Underground Railroad. So it seems probable that at least some of New Britain's slaves joined the people escaping slavery from the Southern states. Others gathered together in a small neighborhood that existed for most of the 19th century.

There are two local 19th-century historical and genealogical books that provide details on African Americans of early New Britain, one written by Alfred Andrews and one by David Camp. Other than the state probate records, these books provide most of the written accounts of African Americans in the first 100 years of New Britain. This includes London, the "faithful" servant of Maj. John Paterson, who fought alongside his master in the Seven Year's War.

Perhaps the earliest accounts of free African Americans in New Britain were of Lemuel Lumady and a man known only as "Old Jack." Lumady was born in 1815 and worked in one of the North family's manufactories. His obituary said that he "was regarded as a pioneer resident and treated as such." Old Jack worked in the stables in the 1830s and was known both as a hard worker and a wily character.

Eventually, more African Americans began migrating back to New Britain in search of factory work. Beginning after World War I and especially during World War II, immigration from Puerto Rico and other Hispanic nations brought new ethnic waves of residents.

Diversity in 19th-century New Britain was largely similar to that of other cities that were destinations for immigration. Typically, arrivals to New York were attracted by good wages and steady work in a serene but prosperous New England town. Unfortunately, a hard dose of reality often met immigrants upon boarding steam liners to Hartford, when they were directed to make the passage in the horse cabins, regardless of the fare they had paid. After arrival, immigrants faced discrimination and prejudice on the streets, on the school grounds, and at work. Assimilation was difficult in many cases, but this did not deter them from staying, or deter more immigrants from making their way here. The steady work and freedom found here was better than the political upheaval, military conscriptions, dictatorships, and destitution these new residents had left behind. The Irish were the first to arrive, beginning around 1840. They established themselves largely in the area eventually called "Dublin Hill." The Germans were the next major group; they were quickly hired for their reputed mechanical skills. Other groups followed, in particular the Polish, Italians, Swedish, Russians, and Lithuanians, all of which outnumbered the Germans and the Irish. By the early decades of the 20th century, arrivals from Austria, Syria, Armenia, Turkey, Greece, and China further populated the city.

Immigrant laborers generally found lower wages and longer hours at work than their native-born colleagues; sometimes, they could not find a job until a strike cleared out a factory. Despite this, the immigrant population of New Britain thrived, built their individual communities, and assimilated to varying degrees. One need only look around to see the evidence of this in the numerous church steeples and towers—places of worship of all denominations. New Britain also has the distinction of having the largest Polish population in Connecticut, with a thriving district known as "Little Poland."

New Britain's multiple ethnicities maintain their communities through churches, social clubs, and community centers. At the same time, one can find evidence of how all ethnicities work together, from City Hall to the factories. New Britain has long identified itself as a cosmopolitan city largely defined by both its individual ethnic groups as well as the totality of its diverse population. This chapter tells of some of the representatives of this diversity—men and women who are considered pioneers or leaders in their communities, contributing both to their community's advancement as well as that of the city in general.

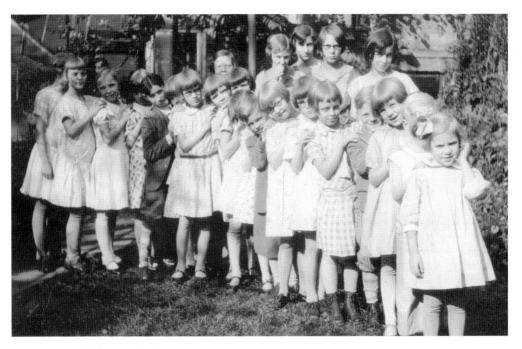

Klingberg's Children's Home

The children of immigrants during the industrial revolution probably suffered as a whole more than children of any other period in the United States, and this was the case in New Britain. Most tragic were the cases of children who were abandoned or orphaned due to circumstances related to the times. It is difficult to imagine having to abandon one's children. Some immigrants sent their children first to live with relatives, and somehow never made it themselves. Others were forced to work all day for little pay and were simply unable to care for their children. Until Rev. John Klingberg began his children's home, many of these children simply lived on the street or in abandoned shacks. Children such as those shown in these photographs quickly filled Klingberg's homes and were given the best lives possible. (NBHS.)

Joseph Pierce (1855–1916) (OPPOSITE)

Joseph Pierce was born in Canton, China, and at the age of 10 was sold by his father to the captain of an American merchant ship. The crew nicknamed him "Joe," and he probably would have spent his youth as a cabin boy (a ship's servant). However, the captain, Amos Peck III of Kensington, chose to adopt the boy, naming him Joseph Pierce, after the presidential candidate Franklin Pierce. Joseph was raised by Peck's mother at their Chamberlain Highway home, attending school with Amos's younger siblings. Amos himself was usually at sea, coming home between voyages. Although most Chinese immigrants at this time were only seen running businesses, such as laundries, Joseph Pierce was an accepted member of the community, likely due to the prominence of this family. After school, he worked the family farm until 1862, when he answered the call to duty. New Britain was the hometown of Company F, 14th Connecticut Volunteer Infantry. War meetings were held in First Church, where men like Pierce would enlist and then be mustered outside at Central Park. Pierce fought alongside many sons of New Britain in some of the bloodiest battles of the war. He was injured in the Battle of Antietam and returned just in time to join his unit at Gettysburg. There, he volunteered for an attack on Bliss Barn, where he and a handful of others successfully defeated a holdout of Confederate sharpshooters. He was then promoted to corporal, the highest rank of the handful of Chinese Americans who fought in the Civil War.

After the war, Pierce settled down in Meriden, Connecticut, where he took part in the silver trade that his adopted sisters had married into. In 1876, Pierce married an American woman, Martha Morgan, 18, another tribute both to Pierce and his community for overcoming the social norms that usually kept Chinese immigrants segregated. The Pierces had four children, two daughters and two sons; only the sons survived to adulthood. Pierce worked for the Meriden Britannia Company, a silver-plated housewares manufacturer, for a period of 26 years. He retired at the age of 72 in 1914, a year after finally being granted a military pension. He died in 1916 and was buried in Walnut Grove Cemetery, less than a mile from his Meriden home. His country remembered his participation and contributions by providing a monument to mark his gravesite. (The 14th Connecticut Volunteer Infantry.)

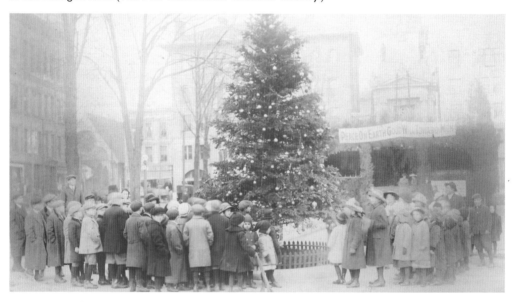

Elise Traut (1855–1923)

Brought to America as a baby, Elise arrived in New Britain in 1888 upon marriage to Justus Traut. She wrote a number of publications dealing with domestic issues for the modern working family, as well as the establishment of Christmas as a holiday. Traut once observed neighborhood children decorating a bush, discovering that this was their only Christmas tree. Thereafter, she created a fund to start and maintain the municipal Christmas tree in Central Park. (NBPL.)

Dr. Andrew S. Wesoly (1911–1994)

The widow of A.J. Sloper, wanting their home to be used for good, sold it to Dr. Andrew S. Wesoly. Born in New Britain to Polish parents, Wesoly was a doctor, and his wife, Cecelia Kremski-Wesoly, a civic leader. They used the first floor for his medical practice, which served patients of the Polish community. He received great honors for his tireless dedication to his community. (NBHS.)

Sgt. Joseph Sokovich (c. 1900–1918)

Sokovich was in Company I, 102nd Infantry, 26th Division ("Yankee Division") of the World War I American Expeditionary Force. He was killed in action during the Battle of Seicheprey, a surprise German attack on the first American arrivals on April 20, 1918. Not only involved in the first American battle, Sergeant Sokovich is noted in New Britain history as being the first Polish American to die in the war. (NBPL.)

Arthur J. Unaris (1919–2007)
Art Unaris (left) is known for transforming a classic hot dog lunchroom into an icon of New Britain culture—Capitol Lunch. Born in New Britain to a Greek family, Art and his brother-in-law, Nicholas Sangeloty, bought Capitol Lunch from Peter Lampros in 1956. Lampros had founded Capitol Lunch in 1929 and created a sauce for his hot dogs that some describe as a unique chili sauce and some as a meat sauce with hints of Greek spices. The hot dogs are a special variety made locally by the Martin Rosol Company. Unaris was known for his friendly service; he even invited in youths who were wandering the streets after school while their parents worked in the factories. To this day, the unique flavor of "Cappie Dogs" are enjoyed by everyone from construction workers to politicians. Art Unaris, the face of Capitol Lunch for 45 years, created a legend that has been upheld by his son-in-law and grandchildren, Gus Ververis, Art Ververis, and Gus Ververis Jr. (Left, courtesy Helen Unaris and Ververis family; below, NBPL.)

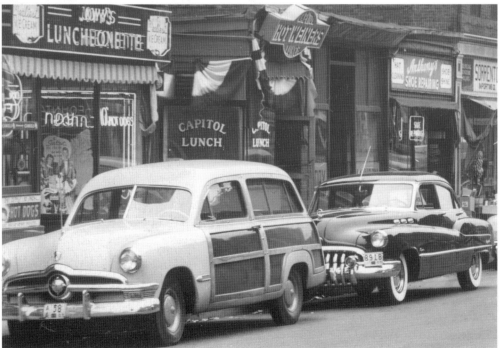

Abraham A. Ribicoff (1910–1998)

Ribicoff was born in New Britain to Ashkenazi Jewish immigrants from Poland and raised in a tiny flat in a six-unit tenement on Star Street. His parents were of limited means but valued education; they sent him to public schools and insisted that he work to save money for college. He worked after high school at the Prentice Company to complete his college fund, and in 1928, he enrolled at New York University. His company transferred him to Chicago, and he entered the University of Chicago law school. While working and attending school, Ribicoff was married, had children, and served as editor of the law school's newspaper. He received his law degree cum laude in 1933, and he was subsequently admitted to the Connecticut bar. Now able to move to his home state, he began practicing law for a Hartford firm, then he set up his own practice in Kensington and later in Hartford. In 1938, he became a member of the Connecticut State Legislature, serving until 1942. Ribicoff was also a judge in Hartford until 1947. He then was elected, as a Democrat, to the US Congress, serving from 1949 to 1953. He returned home again and was elected governor, serving between 1955 and 1961. The first Jewish governor of Connecticut proved his leadership and ability to secure bipartisan support while working to rebuild the state that had been ravaged by floods in 1955. Ribicoff was on hand at the 1956 Democratic National Convention to nominate his fellow New Englander and longtime friend John F. Kennedy for vice president. He later publicly endorsed Kennedy's presidential campaign and then served on Kennedy's cabinet as secretary of health, education and welfare. In 1962, Ribicoff was elected to the US Senate, where he opposed the handling of the Vietnam War and allied with Ralph Nader to create the Motor Vehicle Highway Safety Act of 1966, which created the National Highway Traffic Safety Administration (NHTSA). He turned down the vice presidential nomination on the George McGovern ticket, instead remaining in the Senate until he retired in 1981. Today, Star Street is gone, having been redeveloped into a public housing complex. One of the senior apartments on Martin Luther King Drive, not far from former Star Street, is called the Ribicoff Apartments. (NBPL.)

Ambrose Beatty (1831–1900)

Born in Ireland, Beatty came to New Britain in 1856 and worked for Russell & Erwin and then in the grocery business. He went on to serve in several public offices, including as fire department chief, the state's first Irish-born mayor, city postmaster, and state legislature. An eloquent spokesman for the poor and the immigrants in this city, as well as a devoted activist in civic affairs, Beatty earned much respect and admiration. (NBHS.)

Anthony T. Bianca Sr. (1920–2012)

Born and raised in New Britain, Bianca attended Hillyer College in Hartford. He proudly served during World War II as a staff sergeant in the 87th Infantry, 345th Regiment of the US Army in Europe. He saw frontline action in Germany, France, and Belgium, and fought at the Battle of the Bulge. Bianca received a Combat Infantry Badge, Purple Heart, Army Presidential Unit Citation, and the Bronze Star for Heroic and Meritorious Achievement. After the war, he was involved in a variety of business ventures, in sales, advertising, land development, and construction. He and his son Anthony Bianca Jr. created ATB Construction Management, Inc., a real-estate development firm. Bianca was active in a variety of local community and veterans' organizations and was a corporator for New Britain Girls and Boys Club, New Britain General Hospital, and Hartford Hospital. Bianca was also actively involved in Democratic politics and was a member of the Democratic State Central Committee, a Democratic town chairman, and chairman of the Democratic Party's Campaign Speakers Bureau. He organized state campaigns for John Glenn, Robert Kennedy, John Kennedy, and Adlai Stevenson. Not only did Bianca become acquainted with these and other politicians, it may be more than coincidence that the state's political affiliation as the result of elections became strongly Democratic during the years of Bianca's campaign work. He is remembered by those of all political affiliations as a pillar of the community, the likes of which is very rare among today's residents. (Anthony Bianca Jr.)

Constance Wilson Collins
(1928–2013)

Born in New York City, Connie Wilson came to New Britain with her mother in 1945, living in very meager housing. This included a flat over a Corbin Place garage and a small shack on North Street. They both worked hard and were eventually able to rent a new but unheated tenement in a three-family home on Belden Street. She later married Alphonzo Collins; they had two children together and even purchased the Belden Street tenement house.

Connie Collins's professional and political career began when she followed her mother into the Landers, Frary & Clark factory in 1951 to obtain a job. She soon became an active member of the plant's union, the United Electrical Workers Union, Local 207. The first woman on the union's negotiating team, she soon earned the position of president of the local union. She also began campaigning for New Britain mayor John Sullivan and Abe Ribicoff's bid for state governor. Ribicoff, a New Britain local who grew up near Collins's North Street shack and in similar circumstances, was elected governor and went on to national politics. Collins would go on to campaign for local, state, and national politicians, including John F. Kennedy.

In 1969, she became the first African American elected to New Britain public office, as alderwoman on the common council. She served for four terms, using her interpersonal abilities to show voters that she was qualified not because of race, gender, or platform, but because she truly cared about her community. One of her memorable accomplishments was the successful spearheading of the renaming of Hartford Avenue to Martin Luther King Jr. Drive.

Collins has been honored with over 25 awards and citations, including Who's Who in Black America, Connecticut's 1979 Outstanding Woman of the Year, and New Britain's 1995 Black Leadership Solidarity Recognition Ceremony. She earned a master's degree in education from Harvard University. Her numerous positions on local, state, and national organizations allowed her to champion and support causes for women, minorities, workers, unions, community development, education, and the church. Collins holds a place among the city's greatest civic leaders, and she is remembered by friends and colleagues for her cheerful determination and heartfelt devotion to her causes and community. Her children carried on her values and dedication to community service; her daughter currently serves as alderwoman on the common council. (City of New Britain.)

Carmen E. Espinosa
Espinosa and her parents emigrated from Puerto Rico to New Britain in 1952. Inspired by her parents' work ethic, she attended college and earned a law degree. Her career included government positions as an attorney and judge, and she was a superior court judge in New Britain for some time. In 2013, Espinosa became the first Hispanic justice of the Connecticut Supreme Court. She is seen here being sworn in to that position by Gov. Dannel Malloy. (State of Connecticut, Office of Governor Dannel P. Malloy.)

Chief Clifford J. Willis (1924–2001)
Willis came to New Britain as a boy, when his family moved here from the South. He was drafted in World War II and served in Europe in Gen. George Patton's Red Ball Express. He later received a criminal justice degree from Central Connecticut State College, then was hired by the New Britain Police force. Willis became the first African American chief in 1982, proving to be a leader devoted to his position and community. (NBPD.)

Adrian M. Baron

Adrian Baron received his juris doctorate from the Pace University School of Law in 2004, also earning a certificate in international business law and trade through the Uniwersytet Jagiellonski in Krakow, Poland, and the Columbus School of Law in Washington, DC. Pictured here with "Stanley the Dragon," Baron, as executive director of the Polonia Business Association, successfully lobbied in 2008 to have New Britain's Polish district officially named "Little Poland." (Adrian Baron.)

Little Poland

New Britain's Broad Street has been home to a considerable number of Polish businesses and families since 1890. In 2008, it was officially titled "Little Poland." It is a culturally and economically vibrant neighborhood, and one sees the Polish language on storefronts, billboards, and newspapers. A variety of traditional products, services, and cuisine are offered. The residents maintain traditional and modern ties in a way that creates an ideal ethnic community. (Adrian Baron.)

Officer Armando Elias

The story of Armando Elias (left) represents the pride and confidence of New Britain's Puerto Rican community. He started his life in New Britain, and, although he moved to Puerto Rico while still young, he always remembered the wading pool (below) at Walnut Hill. This former reservoir was used as a pool in the summer and as a skating rink in the winter for decades before being filled. Elias grew up in Puerto Rico, serving as a police officer there before joining the Army's 82nd Airborne Division, becoming a decorated sergeant. He returned to New Britain, joining the police academy in 2006 and becoming a highly praised police officer. Elias has been known as an active promoter of better relations among the city's diverse people, both within the department and between the community and the department. (Right, NBPD; below, NBPL.)

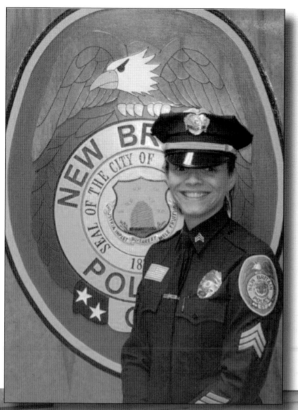

Lt. Jeanette Saccente

Saccente (left) grew up in a New Britain housing project and graduated from New Britain High School. As a child, she had much interaction with the city, and she fondly remembers accompanying her father downtown to Jimmy's Smoke Shop (below) to purchase Spanish-language magazines. Jimmy's, opened in 1928, is a fixture of old New Britain. Workers and travelers alike stop in for a smoke, a newspaper, a magazine, or conversation. After high school, Saccente attended college while serving in the Army Reserves, gaining a practical education and acquiring the desire to be a detective. She was accepted into the police department and rose to the rank of sergeant. In 2013, Saccente was promoted to lieutenant, not only becoming the highest-ranking female of the department, but also the head of an entire team of detectives in the criminal investigation division. (Left, NBPD; below, NBHS.)

CHAPTER SIX

Crime and Law Enforcement

The first local law enforcement position, and the oldest office in New England, was the constable. John Stanley, the immigrant father of the Stanley family, was constable of Farmington in 1654. Selected by the town or society, the constable would patrol the area and enforce laws in accordance with the magistrate or the pastor. Reverend Smalley once responded to the increasingly non-Puritan ways of the younger generation by publicly calling for the constable and magistrate to enforce the laws of the colony against vice and immorality. New Britain has a record in 1775 of storekeeper Elnathan Smith serving as local constable, and Col. Isaac Lee is known to have served 30 years as local magistrate. Lee was known for overpowering men with his wrestling abilities and standing up to groups of men in the interest of keeping the peace.

If the stern lectures of Reverend Smalley or the thought of being tossed like a cider barrel by Colonel Lee were not deterrent enough, offenders might find themselves sentenced to lashings at the whipping post. In the early 19th century, one was erected near Central Park on Main Street. One of the few actual accounts was that of an early-19th-century father and son, who, for some reason, stole clothes drying on a line.

Alva West Spaulding was the first town constable, in 1850. He then served as the first city police chief in 1871. The force was small for the first couple of decades, and on a typical night, it was not unheard of for one patrolman to be on the street and one officer at the station. As the population swelled, however, so did the number of crimes, and the city expanded the force to protect citizens and businesses. The first station was a small brick and stone building known as the "Watch House" or the "Tombs." It consisted of four small cells, each with a brass basin and a mound of straw to sleep on. The city would see two more stations, and in 2012, the current station was completed at the corner of Main and Chestnut Streets. This station was built with cosmetic and functional amenities, such as a community event room and retail space, that helped integrate it and the police department into the downtown district. Additionally, the latest in law enforcement technologies were included, such as a simulation room that emulates the interior of various New Britain buildings.

As mentioned earlier, much of the popular history of New Britain is related to events and crimes that law enforcement was involved in, and the men involved became local legends. An event in the early years was the confrontation that ensued when news of the Revolutionary War broke in Connecticut one Sunday. Smalley did not like the idea of a violent revolution, and he misjudged his flock when he scolded them for preparing to fight. Tensions were already high, and the militia men's outrage was approaching violence before Colonel Lee came between them with his strong presence and demanding voice, reminding the men that they should forget this local misunderstanding and prepare to fight their real enemy. Lee made sure that Smalley followed through with a proper apology, which was printed in the *Hartford Courant*, to ensure that he could continue preaching and regain the respect of the church members. As the city grew and immigration diversified the workforce, labor disputes occasionally occupied the police department

in the 19th and early 20th centuries. The rise of the great banks and the general prosperity of businesses also meant that criminals were attracted to the large sums of cash in New Britain's vaults. Police were called to keep order during visits of politicians, including a number of presidential visits. Youth gang violence resulted in tragedy in 1934, when a group killed the 14-year-old son of a deputy fire chief and escaped identification. A Ku Klux Klan rally in the 1980s found the New Britain Police Department so well prepared that many dismissed the rally as a "non-event." The rise of illegal gambling as well as Prohibition-era drinking sent many an officer bursting into back rooms and hotel rooms. Finally, some officers became local legends for the duties they performed. Some of these officers were pioneers on the force, and all of them proved ready to put their lives on the line for their community. This chapter includes some of these memorable figures in New Britain crime and law enforcement.

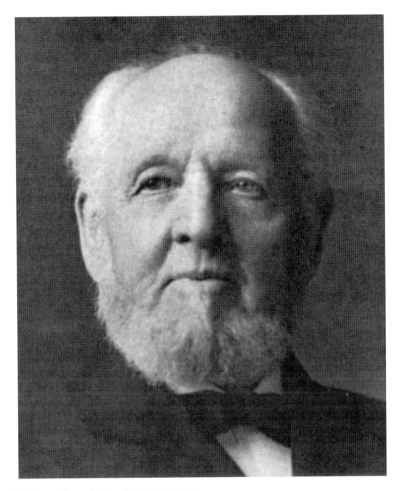

Chief Alvin West Spaulding (1825–1906)

A.W. Spaulding was born and raised in Morristown, Vermont, arriving in New Britain in 1847 with only 25¢ in his pocket. He was given his first job, in the livery business, by George Hart. Spaulding eventually went into the livery business himself, continuing in it for over 30 years. In 1854, he married Josephine A. Beckley of Berlin, and they adopted a son named Clinton. Spaulding served as the Town of New Britain's constable, the city's first supernumerary officer, and a part-time deputy sheriff of Hartford County, becoming highly respected for his tenacity and grit and his dedication to upholding the law and justice. In 1870, he was elected one of the representatives to the general assembly from New Britain, serving with T.W. Stanley. In April 1871, the City of New Britain appointed Spaulding as its first police chief. He then took control of the "Tombs" at 13 Commercial Street. He was provided with three active policemen and a supernumerary force of eighteen part-time officers. His niece, Mary Darling, was the wife of Lt. Levi H. Robinson, who, in 1874, was killed during a Sioux uprising at the Red Cloud Agency. Mary was with child, and, as her father had been killed by another Native American uprising in Texas, she came to New Britain to live with her uncle until she remarried. Spaulding would remain police chief for over 10 years and was then subsequently elected sheriff of Hartford County, an office he held until 1901. He then returned to New Britain, continuing to be in charge of the jail. He became ill with pneumonia on January 1, 1906, and grew rapidly worse. He died at his home, at 91 Vine Street, on the morning of January 8, at the age of 81. The funeral was held at his home on January 10 at 1:00 p.m. He was buried in Fairview Cemetery alongside Lieutenant Robinson. A year after his death, a horse thief impersonating A.W. Spaulding was arrested in Hartford. (NBPD.)

William F. Walker (1846–1922)

Walker was the son of Rev. William Walker, a former pastor of the Baptist Church in New Britain. He married the younger sister of A.J. Sloper. Unable to find a job, he turned to his banker brother-in-law for help. Sloper managed to get him a job as treasurer of the Savings Bank of New Britain. Walker managed to prove himself capable, and yet was paid very little due to his inexperience. So little, it turned out, that he attempted to keep himself in the economic status of his peers by speculating in dubious Wall Street schemes. These schemes, it turned out, were meant to take the money of the likes of William Walker rather than make money for all involved. So, while at the time nobody expected this mild-mannered man capable, many thought, when discovering the full details, that it was not that surprising that Walker turned to theft to get himself out of a jam. What was surprising was that Walker not only took $500,000 in bonds from the bank, but about $50,000 in cash from the Baptist Church. Walker simply disappeared one day in 1907, then sent a telegram in an attempt to tell everyone that he had been killed. A week later the theft was discovered, and then Walker sent the bank a written confession and some details of how he lost his money. As it turned out, when Pinkerton detectives finally caught up with him at the end of the year in Mexico, Walker had lost all of the money he stole. He was extradited and imprisoned until 1915, when he was paroled. He lived a quiet life after that back in New Britain for the next seven years. After his death, it was found that he had made one final act of charity, financially supporting a widow and her destitute children in France. (NBPL.)

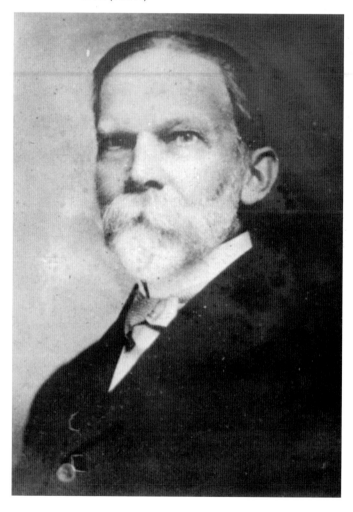

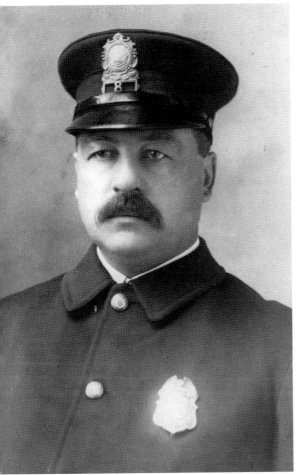

Frank M. English (1855–1925)

One of New Britain's longest-serving and oldest officers, English had served 34 years when he died on duty at age 70. Born in Ireland, English first came to Massachusetts, where he met and married Julia Conway. He and his brother Michael English then moved to New Britain, where Frank joined the police force in 1887. A familiar sight walking his beat on Church Street and at the railroad station (below) and arcade, he always had a smile on his face. Although diligent, English was known to converse with the public without the slightest hint of officiousness. He lost his first wife and daughter, but eventually remarried and raised four children on Fairview Street. In June 1925, the city was gripped by an intense heat wave, with temperatures climbing to 110 degrees. The city armory opened up its showers for residents to cool off, as there was no air conditioning. That morning, Officer English's wife begged him not to go to work. Although in generally good health, his required uniform was a high-collared jacket and hat that would give even a younger man heat stroke. Officer Frank English reported for duty at 7:00 a.m. that day and died doing what he loved—walking the beat in the town he had called home for over 50 years. (Left, NBPD; below, NBHS.)

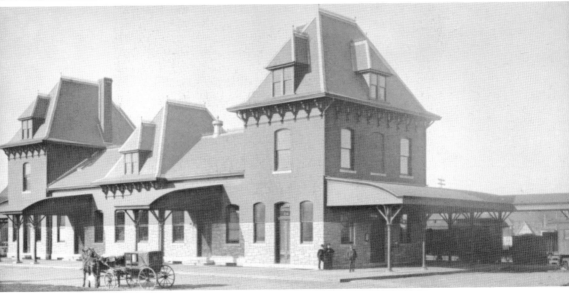

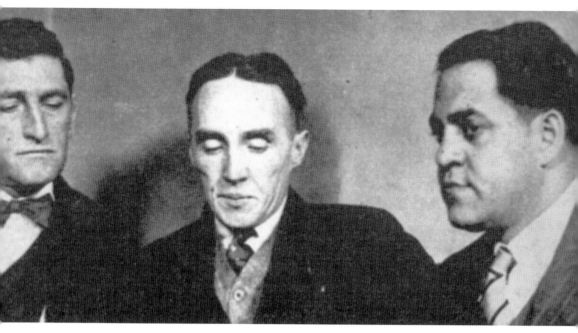

Gerald Chapman (1887–1925)

Known as the "Gentleman Bandit" and the "Count of Gramercy Park" for his suave appearance and demeanor, Chapman (pictured center) was an opportunistic thief and cold-blooded killer. Born George Chartres to parents of Irish heritage, he was arrested for the first time at age 14 and was incarcerated for the majority of his early adult life. After his first conviction on a bank robbery charge, Chapman was imprisoned between 1908 and 1919, during which time he befriended George "Dutch" Anderson. After both men were paroled, they began bootlegging operations in Toledo, Miami, and New York City over the next two years. In 1921, they began committing armed robberies with another fellow inmate, Charles Loeber. Their greatest heist was of $2.4 million from a mail truck. After eight months, Chapman and Anderson were captured by postal inspectors and sentenced to 25 years. Unfortunately, they both escaped the following year and continued their operations. In 1924, Chapman was on a crime spree in Connecticut when he somehow came upon the Davidson & Leventhal Department Store in New Britain. The store had a backroom safe and, even better, a back door that was accessible by a series of dark alleyways. Unfortunately for Chapman, these alleyways were still used for livery stables, and a livery hand spotted him breaking in, reporting it to the police station. Then, four officers arrived; two had just entered the store when someone ordered them to "Get down there again or I'll kill you!" and started firing. One officer took cover behind a counter, but veteran Patrolman James Skelly was struck, believing he had suffered a leg wound. In fact, Skelly had been shot near his ribs, and the bullet traveled downward, severing an artery and punching 16 holes in his intestines. The suspect escaped. Skelly was taken to New Britain General Hospital, where he died in surgery. Chapman's accomplice, Walter E. Shean, was apprehended by another officer near the Herald building. The officer obtained a briefcase containing evidence of the safe job. Shean identified the shooter as Chapman, and a manhunt ensued, with the press for the first time using the term "Public Enemy Number 1." He was eventually found, extradited to Connecticut, and sentenced to hang on April 6, 1926. (NBPL.)

James Skelly (1868–1924) and William Grabeck (1898–1951)

Skelly and Grabeck, the only officers in New Britain to be killed in the line of duty, are considered local heroes and examples of officers who put their lives in danger for their community. Born in Dublin, Ireland, Skelly came to the United States at age 21 and joined the New Britain Police Department in June 1906. He was an 18-year veteran patrolman when the station received a call about a break-in at the D&L store. There were three patrolmen were at headquarters, and a fourth had just arrived in his personal vehicle. The officers immediately jumped in his car and drove to the store, just down Main Street. The officer who took the report from the witness was waiting at the call box, and when the other officers arrived, two pursued and apprehended one of the suspects who had fled the scene. Then, two officers entered the store to arrest the other burglar, but were fired upon by Gerald Chapman. Gravely wounded, Skelly was rushed to the hospital. Chapman fled the scene. Patrolman Skelly died on the operating table during surgery, which was attempted to save his life.

Grabeck served with distinction in World War I, having received more citations than any other New Britain man to that time, including a Silver Star with three Oak Leaf Clusters. He joined the police force a year later and was promoted to sergeant in 1937. He was planning to lead the platoon in the Armistice Day parade on November 11, 1951. On November 5, Officer Theodore Wojtusik was driving Sgt. Grabeck home. On their way, they heard a call about a holdup in progress at the A.Y.O. Packing Company on Washington Street, and they responded. People were still at the sausage plant, including a man and his wife, who were hiding. Sgt. Grabeck entered the building and found Frank Wojculewicz, waving a revolver. Grabeck placed his revolver at the robber's back and ordered him to drop it. For some reason, a man jumped out of hiding and interfered, and Wojculewicz spun and shot Grabeck five times. Grabeck fired six times, wounding Wojculewicz. Patrolman Wojtusik responded from the rear of the building and arrested the injured suspect. Both Grabeck and Wojculewicz were brought to New Britain General Hospital, where Grabeck died and Wojculewicz was found to be paralyzed. (NBHS.)

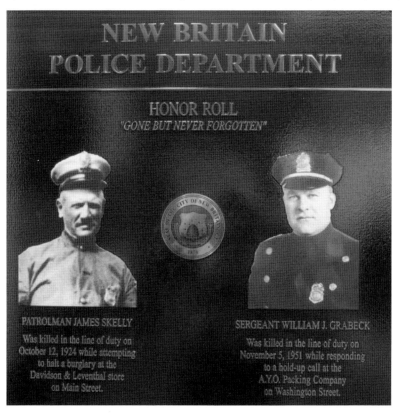

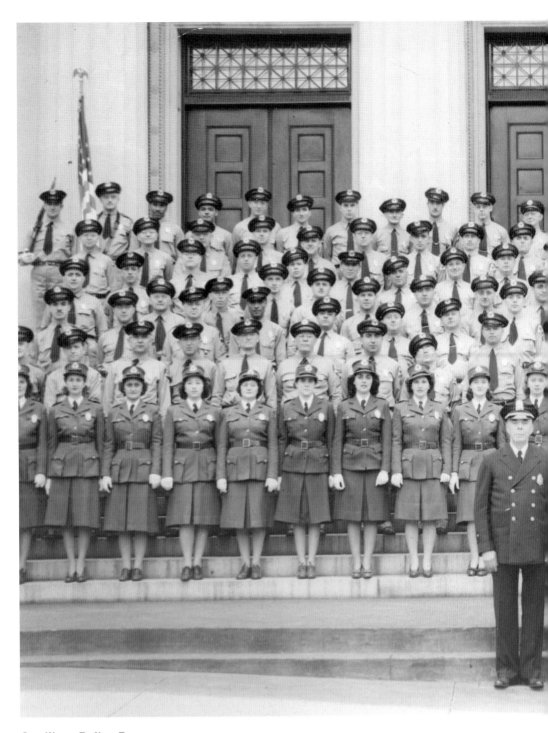

Auxiliary Police Force
During World War II, many women worked shifts at the factories, and the police force was hard-pressed, with its reduced ranks, to keep these women safe as they walked to and from work at night. While women could not join the regular force, the department created the Auxiliary Police Force.

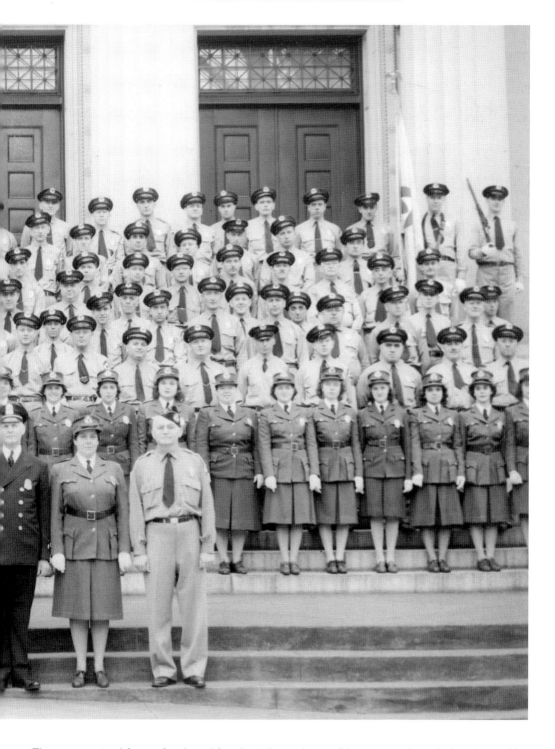

This was a trained force of male and female civilians who would assist patrolmen by keeping a wider watch on their beats and even assist with incidents. At the Hartford circus fire in 1944, the New Britain Auxiliary Police Force helped clear the way for rescuers. (NBPD.)

Chief William C. Hart (1881–1958)

Chief Hart was born in New Britain and joined the police force in 1904. He became chief in 1922 and remained in that position for 29 years, until his retirement in 1951. His tenure as chief began during Prohibition, conducting raids on liquor-serving establishments, shutting down bootlegging operations, and even fighting unfounded allegations that his own family was involved in bootlegging. He was chief when Gerald Chapman murdered Patrolman Skelley, and Hart is credited with furnishing the tip that led to Chapman's arrest in Indiana. Hart was also in office when the city and state cracked down on illegal gambling operations in hotel rooms and elsewhere in the city. Hart retired after 47 years on the force and passed away about seven years later. (NBPD.)

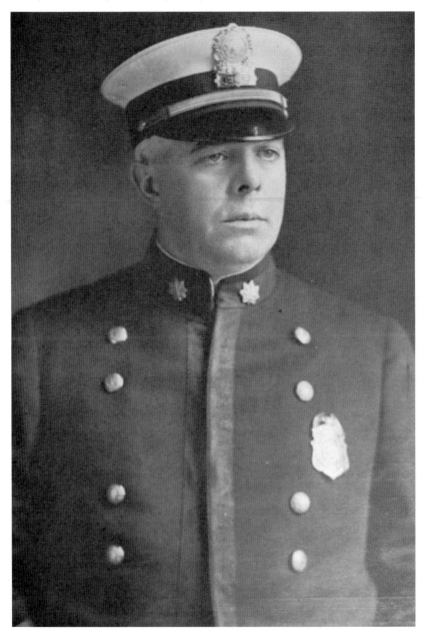

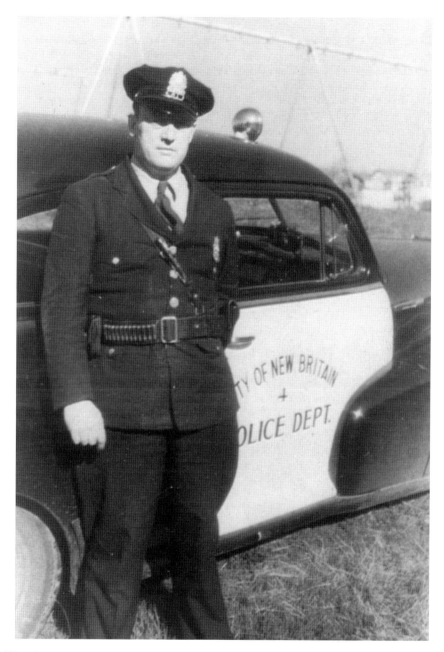

Chief Daniel J. Cosgrove (1896–1957)

Chief Cosgrove was born in New Britain, a son of longtime officer Michael J. Cosgrove. After high school, he worked at Stanley Rule & Lever from 1909 to 1924. He started on the supernumerary force in 1917, served in the Navy during World War I, and was hired on to the regular police force in 1924. He began his tenure as a part of Chief Hart's "dry squad" during Prohibition and quickly rose through the ranks. "Danny" Cosgrove was known for his warm and infectious smile, which made him well-liked on the force and in the community. Although steadfast in his devotion to duty, Cosgrove had a way of putting his fellow officers at ease. He became chief after the retirement of Chief Hart, but he died unexpectedly within six years of office. (NBPD.)

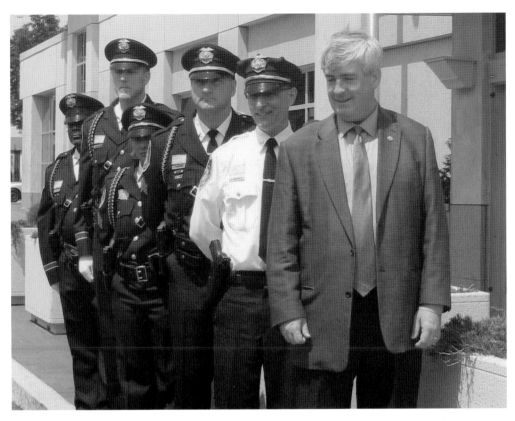

Chief James P. Wardwell (b. 1962)

James Wardwell (pictured second from right) is a descendant of the Massachusetts Wardwell family, including Samuel Wardwell, who was among many wrongly convicted in the Salem Witch Trials and whose brave actions before his execution helped bring an end to that dark chapter. It seems therefore fitting that James Wardwell would devote his life to excellence and advancements in police investigative work. Wardwell grew up in the neighboring town of Bristol and ran a small business there for a number of years, at the same time taking courses at Central Connecticut State University. Wardwell joined the New Britain Police Department in January 1994, soon being promoted to investigator in the youth bureau. He initiated New Britain's first digital forensic examinations, and, while conducting computer investigations in the late 1990s, he developed a digital forensic laboratory. He even developed a method for recovering deleted electronic evidence, work for which he and the department would gain national recognition and certifications. In 2000, Wardwell was promoted to detective as part of the criminal investigations bureau until 2004, at which time he was trained as the New Britain Police Department's first polygraph examiner. He set up New Britain's polygraph unit and was again honored for his pioneering work, earning a promotion to sergeant and supervisor of the newly formed digital forensic unit in the criminal investigation division (CID). In 2007, he was promoted to lieutenant and then was given command of CID. Wardwell served as the acting captain of CID until being appointed as the interim chief of police in 2012, after the retirement of Chief Gagliardi. Wardwell was sworn in as police chief in January 2013, taking command of the new police station that had just been completed on Chestnut Street. (NBHS.)

Chief William J. Rawlings (1853–1943)

Rawlings was born in the neighboring town of Berlin to an English immigrant family. As a young man, he began working in New Britain for Churchill & Lewis, the oldest jewelry manufacturer in the United States. He also served as a volunteer firefighter and a deputy sheriff, then enlisted in the Army when the Spanish-American War broke out. Although promoted to lieutenant, Rawlings returned to civilian life after the war, becoming chief of police in 1900. When Prohibition was enacted, Rawlings ensured that New Britain's saloons closed. A respected leader, Rawlings was tough and military-like in demeanor. He called his vice squad the "strong arm squad." Rawlings retired from the force in 1922, focusing on his work in the savings and loan industry. (NBPD.)

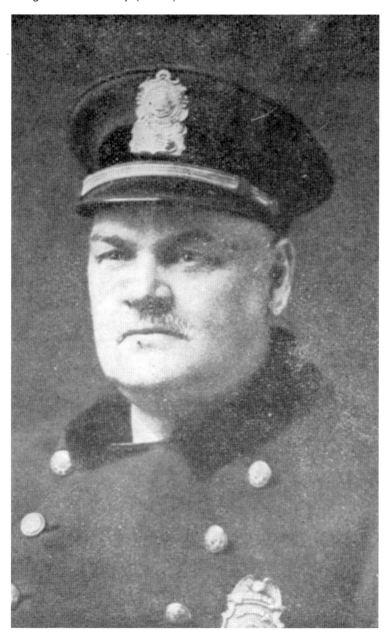

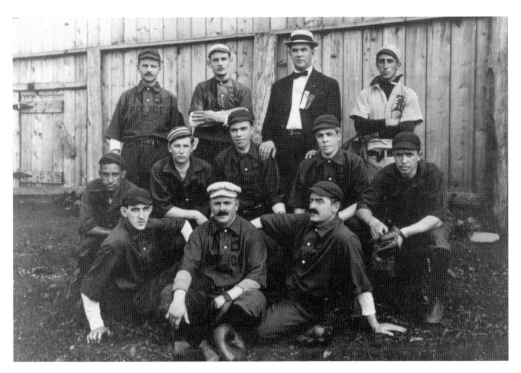

New Britain Police Baseball Team

The New Britain Police Department began in 1909, and it joined the ranks of the various companies and organizations around the city with its first baseball team (above). The department formed this team as part of the Police League, which included teams from forces in New Britain, Hartford, Meriden, Waterbury, New Haven, and Bridgeport. The first games were often played at Electric Field in White Oak Park, near the Plainville line. By the 1920s, the Police League was no more, but New Britain still had a team into the 1940s (below) and would play an annual benefit game against the team of the Meriden Police Department, selling tickets and programs to support police pension funds. (Both, NBPD.)

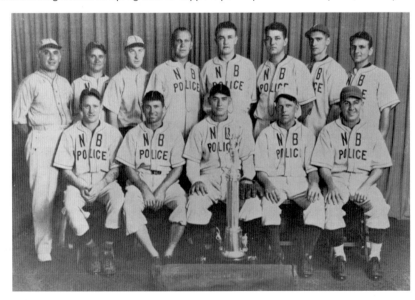

CHAPTER SEVEN

Hard-Hittin' New Britain

Even with the long hours that people worked in the factories of New Britain, people here have always found a commonality in their love for sports. From grade school to high school to the factories, organized leagues and unorganized neighborhood games have kept people interested in both playing and watching. In fact, some exceptionally great athletes developed here and have gone on to become professionals.

One of the earliest documented sports in central Connecticut was wicket, a game that was similar to (and an earlier form of) cricket. As early as 1767, this game was being played in the area, and the Phoenix Wicket Club of New Britain was organized in 1847. Games were played in open lots as well as at Walnut Hill Park and Central Park. Elihu Burritt wrote about a wicket game in one of his newspapers in 1858, the first written account of such a game in New Britain. During the Civil War, an adaptation that would be known as baseball was being introduced, and after the troops returned to New Britain, the Phoenix Club and two other clubs started organizing baseball games in this city. Leagues were organized by individual city wards, companies, churches, fire and police departments, and schools. These leagues primarily played locally among themselves in the parks and empty fields of the city. Industrial leagues were the most celebrated and promoted, as they helped boost pride and morale among factory workers and the city in general. The high school team was extremely popular among students and was very successful in producing strong players for the industrial leagues. In the first half of the 20th century, the police league played annual games with Meriden police to raise money for pension funds. Early on, some promoted the idea of organizing state or national league clubs in the city, but most people seemed satisfied with their local leagues.

In 1884, New Britain joined the state and regional minor league clubs, which lasted until 1914. It was at this time that the first Cuban players were drafted into American teams. It was not until 1983 that New Britain would see professional baseball again, when the New Britain Red Sox began as an AA affiliate of the Boston Red Sox. The current AA team, the New Britain Rock Cats, began in 1995 as an affiliate for the Minnesota Twins. Both of these clubs have done very well in the league and have produced some outstanding major league players.

Baseball is, of course, not the only sport enjoyed by New Britain residents. Football, the other great sports passion of New Englanders, also has roots in New Britain. Walter C. Camp, known as the "Father of American Football," was born in New Britain. New Britain High School (NBHS) has had a hardy and successful football team since 1891. In 2005, the team became the 13th school in the nation to win 700 games. At the time, NBHS was the most successful in the state, having won 30 state championships and 46 conference championships, with several standout players over more than a century of playing.

Basketball is another sport pioneered in New Britain, due to its proximity to the YMCA in Springfield, Massachusetts, where basketball was invented. In 1895, New Britain YMCA members began developing a new technique in basketball that seems today a basic part of the game—the dribble. Early basketball rules stated that the ball could only be advanced when passed. New Britain YMCA members asked the

question, why not pass the ball to oneself by bouncing it forward and then either catching it or continuing to advance and bounce it forward? Although controversial, it caught on quickly. One can imagine the difference in playing this game without the ability to dribble. And while perhaps this was an inevitable improvement of the game, New Britain gained the distinction of being the city where it happened.

New Britain expresses pride for its great athletes through the New Britain Sports Hall of Fame. Located in New Britain Stadium, the hall of fame has plaques bearing the names of accomplished athletes from 1850 to today. The New Britain Sports Hall of Fame Committee holds an induction dinner each year, at which it nominates inductees.

This chapter will highlight some of New Britain's most successful, most celebrated, and most interesting athletes. As to be expected, there are those who found great success as professionals, those who pioneered in their sport, and those who found their goals cut short. New Britain places a great deal of pride in its current and former athletes. Even those with only brief ties, such as spending a season here on a minor league team, are upheld as representatives of Hard Hittin' New Britain.

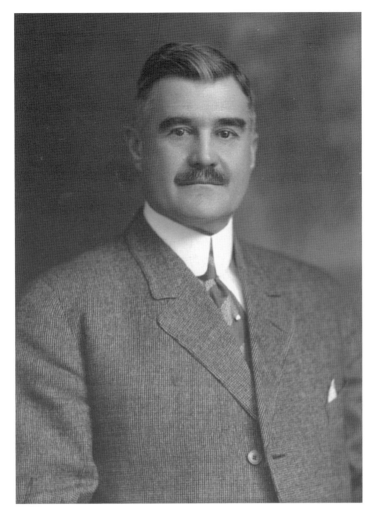

Thomas Lynch (1859–1924)

Lynch is best remembered for his work for baseball's National League, as well as the early days of the Russwin Lyceum Theater. Born in New Britain to Irish immigrants, Lynch loved the game of baseball from his time as a boy. He played for the New Britain High School Golden Hurricanes and, later, for the Industrial Leagues while working at Stanley Rule & Level. Lynch was eventually invited by the National League to work as an umpire. Umpiring in the late 19th century was often perilous, involving virulent and sometimes violent abuse from players, fans, owners, and reporters. Additionally, one umpire served the entire field, so he would take full responsibility (and any ensuing abuse) for every call. Umpires therefore had the choice to remain tough and fair to all, or allow themselves to be corrupted or bullied by teams. Thomas Lynch was one of the few umpires who stayed true to the game, earning himself the title "King of the Umpires." A credit to his steadfastness, Lynch remained an umpire for more than 14 years. He then took a break from umpiring, using his savings to start an advertising business. He also served as superintendent of the city parks and recreation department, coaching baseball teams, and serving in the management for the Russwin Lyceum. During Lynch's time at the lyceum, from its first years of operation and for over 20 years, he and his partners are credited with bringing some of the best and most famous acts in the business to the city. Lynch even served as president of the National League between 1909 and 1913. Lynch was married for 38 years and was a prominent member of the Elks Lodge. (National Baseball Hall of Fame and Museum.)

Steve Dalkowski

Dalkowski was a New Britain native, the son of a working-class family, and a star pitcher for New Britain High School in the 1950s. With a fastball estimated to be more than 100 miles per hour, Dalkowski was eagerly recruited by the Orioles' Triple A club. He was known for a fastball that even the sharpest batters could not see until it appeared in the catcher's glove. His pitches were daunting to even the best hitters of the time, but, due to alcoholism and a learning disability, Dalkowski lacked control. Tales of his wild pitches include ones that shattered an umpire's mask, tore a batter's earlobe, and bounced off another batter's helmet and flew to second base. His managers and coaches tried their best to help him control his pitches, but the mechanics of his wrist-snapping throw were difficult for even Dalkowski to understand. After some intense personal coaching, Dalkowski made it to the major leagues with the Orioles for one season, but he threw out his elbow during an exhibition game, putting him back in the minor leagues. He played until the 1965 season, then retired, living in California. He became a migrant laborer, got married and divorced, and slowly lost himself to alcoholism. It was after his second wife died in Oklahoma City that a former teammate came across him in very bad condition. Dalkowski's sister arranged to bring him back home to New Britain. His prognosis grim, he was placed in the care of the Walnut Hill Care Center, where his recovery surprised everyone. As he began to venture out, rumors of his return and recovery spread. He was even invited to a game for the local Rock Cats baseball team, where he was asked to throw out the first pitch. A happy man, Dalkowski has spent his twilight years back home with his friends and family, watching his beloved sport. (NBPL.)

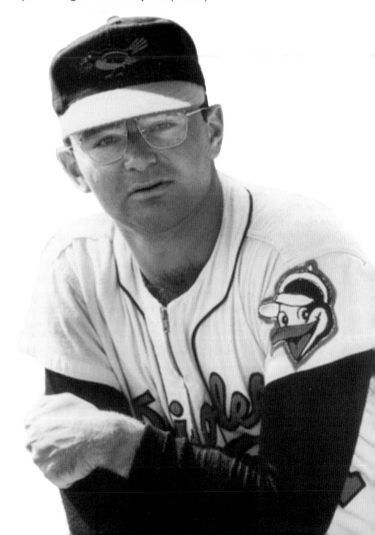

New Britain Base Ball Club 1908.

Reiger p, Coughlin p, Marsans lf, Padron p, Almeda 3b, Rufrange c, Waterman rf, Capt.
Ward p, Brown p, Bunyan 1b, Kerr c, McCabe cf, Cabrera ss, Burns 2b.

Cuban Baseball

It was the New Britain Perfectos, started in 1908, that "imported" the first professional baseball players from the Cuban Leagues. Perfectos manager Charles Humphrey drafted four men from the Cuban Leagues to his team—Rafael Almeida, Armando Marsans, Alfredo "Cabbage" Cabrera, and Luis Padron. As it turned out, the team did very well, as the Cubans complemented the team nicely. The Cubans gained much of the city's affection and support even in tough times, and their contributions to the team were quite obvious when they were away. Thomas Lynch was brought in to help boost cohesiveness, which included celebrating after every game with a pint or so of beer at the tavern. A rivalry with the Hartford team became especially ugly when the Cuban players came into view. Hartford's star pitcher took a particular dislike to the Cubans and, in one game, beaned two of them, knocking Cabrera unconscious for the rest of the game. Padron happened to have a partial African heritage, which was noticeable to the more racist fans, who would taunt him relentlessly. Some managers even went so far as to ban African American players from their fields, putting the team in the difficult position of leaving Padron behind for some games. Humphrey finally decided it was best to release Padron from his contract. Eventually, all four would go on to play in the Negro Leagues, and all except Padron were subsequently allowed to play in the major leagues. The New Britain team would last until 1914. The city was without a professional team for the next several decades. (NBHS.)

Jeff Bagwell

Bagwell went to high school in nearby Middletown, coming to New Britain after being drafted to play on the New Britain Red Sox, the AA affiliate of the Boston Red Sox. After one exciting season, he was not only chosen as the Eastern League's 1990 MVP, he was moved up to the major leagues, debuting with the Houston Astros in 1991. He remained there until 2006, after which he retired. (Michael Glasgow, under Creative Commons Attribution 2.0 Generic license.)

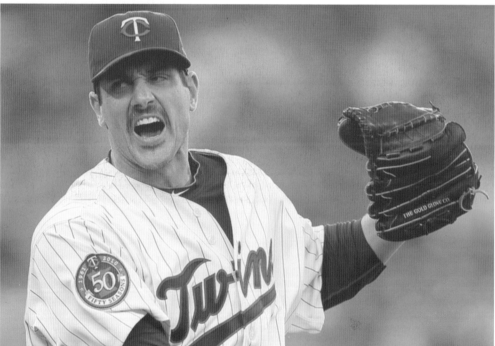

Carl Anthony Pavano

Pavano was born in New Britain in 1976 and went to high school in the neighboring town of Southington, from which he was drafted in 1994 by the Boston Red Sox. Pavano pitched in Major League Baseball from 1998 to 2012 for the Montreal Expos, Florida Marlins, New York Yankees, Cleveland Indians, and Minnesota Twins. He also appeared in the 2004 MLB All-Star Game. (MLB Sluggers.)

Industrial League Baseball

New Britain's passion for baseball translated to decades of amateur teams organized by local companies, under the Industrial League. Of course, there were other corporate sports leagues, such as bowling and basketball, but baseball games played in the parks attracted the most attention. Additionally, company teams helped boost morale and pride among factory workers. The Industrial League had regional ties, often referred to as "Triple-A" (Amateur Athletic Association) baseball. Championships were played between local companies, and then among teams from other towns in the state or beyond. This league peaked with industries into the 1940s, then slowly began to fade in the 1950s and 1960s. (NBPL.)

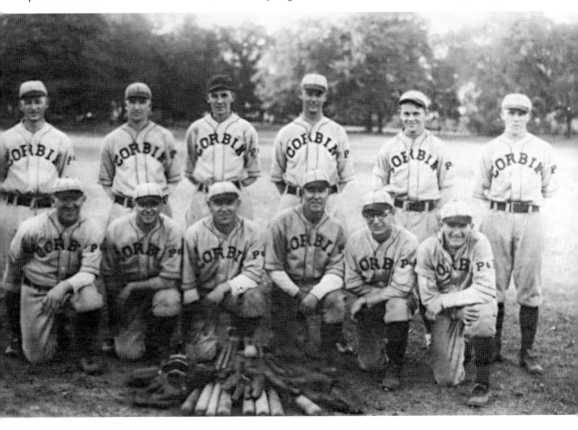

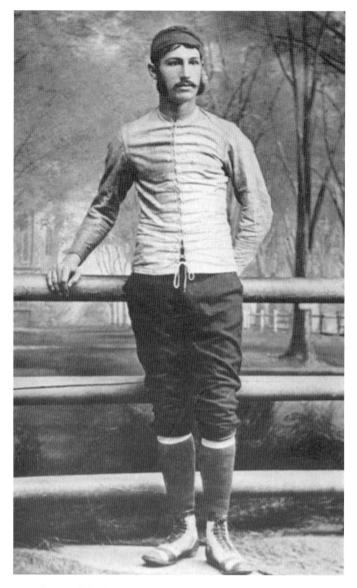

Walter Chauncey Camp (1859–1925)
Camp, an American football player, coach, and sportswriter, was known as the "Father of American Football." Camp was born in the city of New Britain, the son of Everett Lee and Ellen Sophia Cornwell Camp. He attended Yale College from 1875 to 1883, where he was a member of Skull and Bones. In 1873, he was involved in the creation of the Intercollegiate Football Association (IFA), and he was on the various collegiate football rules committees that developed the American game, from his time as a player at Yale until his death. Camp proposed the "line of scrimmage," where the team with the ball started with uncontested possession, thus breaking American football from its rugby origins. He is also credited with the snap from center, the system of downs, the points system, the standard offensive arrangement of players, and the safety. Considered one of the most accomplished persons in the early days of American football, Camp played football at Yale College from 1876 to 1882, then served as the head football coach at Yale from 1888 to 1892 before moving to Stanford University, where he coached until 1895. Camp was inducted into the College Football Hall of Fame as a coach in 1951. (NBHS.)

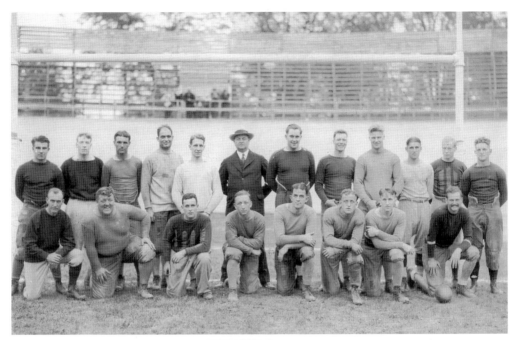

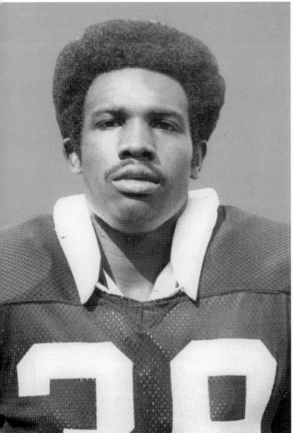

Henry Zehrer (1906–1955) and the Hartford Blues

Zehrer was known around New Britain as a football star. After graduation, he was part of an early attempt to bring the NFL to Connecticut. This was the Hartford Blues, which played one season in 1926. The team practiced in Armory Field in Hartford and played games in the East Hartford Velodrome. The team was 13th out of 22 teams but was cut the next year due to league restructuring. (NBHS.)

Willie Hall

Born in Georgia in 1949, Willie Hall came to New Britain as a youth and attended Pulaski High School. He played in the NFL for the New Orleans Saints (1972–1973) and the Oakland Raiders (1975–1978). Hall was a second-round selection out of the University of Southern California in the 1972 NFL draft. He was a starting linebacker with the 1976 world-champion Oakland Raiders. (NBHS.)

97

Tom Thibodeau
Born in New Britain in 1958,
Thibodeau played basketball
at Salem State University,
eventually becoming head coach
there and then at Harvard.
Between 1989 and 2010, he
was an assistant or associate
coach with various NBA teams,
and then, in 2010, became head
coach of the Chicago Bulls. In
2011, he was named the NBA
Coach of the Year after leading
the Bulls to a 62-win season.
(Keith Allison, under Creative
Commons Attribution–Share
Alike 2.0 Generic license.)

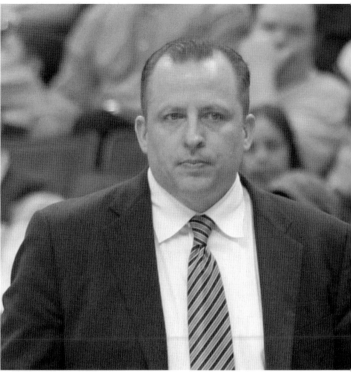

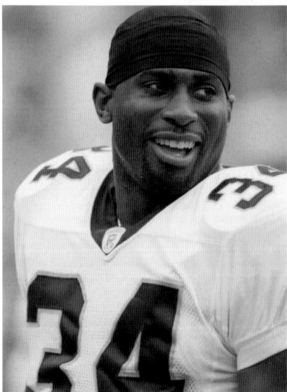

Tebucky Shermain Jones
Jones was born in New Britain in
1974 and attended New Britain High
School, where he lettered in football,
basketball, and track. In football,
he was named the 1993 *USA Today*
Connecticut State Player of the
Century. He played in the NFL (1998–
2006) for the New England Patriots,
the New Orleans Saints, and the Miami
Dolphins. He is currently coaching his
former high school team, the Golden
Hurricanes. (Lucy Media.)

Ryan E. Glasper

Glasper (center) was born in New Britain in 1985 and attended high school in the neighboring town of Southington. At the age of 14, his mother signed legal custody of him over to his then high school football coach, Jude Kelly. He started on the varsity squad his sophomore year, playing a key role as receiver and running back, then for a time as quarterback. Glasper helped lead the Blue Knights to a regional conference title. He played for Boston College, doing very well even as a freshman. Not drafted by the NFL, Glasper decided to sign with the Canadian Football League's Hamilton Tiger-Cats in 2007. He played for a few years with the "Ti-Cats," the Toronto Argonauts, and the Edmonton Eskimos. Glasper came back to Connecticut to play for the United Football League's Hartford Colonials; unfortunately, that team was suspended from the league and disbanded after Glasper's first year. (NBHS.)

Justise Hairston
Hairston was born in 1983 in New Britain, where he played for New Britain High School. He went to Central Connecticut State University, setting a school record and becoming the second player from New Britain's CCSU to ever be drafted by an NFL team. Drafted by the New England Patriots, he played with the NFL between 2007 and 2009 for the Patriots, the Indianapolis Colts, and the Buffalo Bills. (NBPL.)

Tom Myers
Born in Cohoes, New York, in 1950, Myers came to New Britain as a youth and played for Pulaski High School. He played at Syracuse for three years, then signed with the New Orleans Saints. He played with that team for 10 years, then for the short-lived United States Football League (1983–1985). Interestingly, there was another football player named Tommy Myers, who was born in New Britain in 1901. (NBHS.)

Harry Anthony Jacunski (1915–2003)
Born in New Britain, Jacunski was an all-state center on the New Britain High School 1934 basketball team. However, it was at Fordham University in New York City that he developed his love for football. At Fordham, he played with Vince Lombardi and was one of Fordham's "Seven Blocks of Granite." During his final year at Fordham, in 1938, he was co-captain of the football team, starting at the end position. He then played in the NFL for six seasons (1939–1944) as defensive end for the Green Bay Packers, who were NFL champions in 1939 and 1944. In 1945, he started a college football coaching career, with one year at Notre Dame, two years at Harvard, and the last 33 years at Yale. Jacunski was inducted into both the Fordham and Green Bay Packers Halls of Fame. (Fordham University.)

New Britain High School Football

Shown here is a typical New Britain High School game, played in 1947. As the opposing player on the left found out, New Britain's defense is a force to be reckoned with. Since the beginnings of the sport, New Britain's high school teams have been both formidable and prolific in producing star players who have made their mark elsewhere. In this chapter, a few of the notable players from New Britain High School and Pulaski High School have been presented. However, there have been many other local football stars, some who later played the sport and others who chose not to. New Britain High School has been playing football for over a century, producing successful players such as Ed Cody (Chicago Bears), Joe Willis, Len Pare, Kevin Urso, Todd Verdi, Bobby Breau, Tebucky Jones (New England Patriots), Justice Hairston (Central Connecticut State University), Andrew Madigan (Springfield College), and Mike McLeod (Yale). In 2005, New Britain High School became the 13th school in the nation to win over 700 games, ranking fifteenth in the nation and first in Connecticut in all-time wins. It is by far the most successful high school in Connecticut, having won 30 state championships and 46 conference championships. (NBPL.)

CHAPTER EIGHT

Hometown Heroes and World Changers

Certainly, most of the local legends featured in this volume can be considered local heroes in one way or another. This chapter is dedicated to those whose feats or activities are especially interesting, or perhaps do not fit the subjects of the previous chapters. Some of the people in this chapter are of common knowledge in New Britain, while others have been largely forgotten over the years. Some made their mark while in New Britain, such as Alfred Andrews, who was so important to education and the beginnings of the State Normal School. Others went out into the world to pursue and achieve their dreams, such as Robert Barton, who designed some of the most important computing systems of the 1960s. Finally, there were those who came to New Britain for a noble purpose, such as Rev. John Klingberg, who came to create a home for the abandoned, orphaned, and destitute children in the city.

Politics is certainly one area to be covered in this chapter, and New Britain has had its share of great city leaders as well as those who served at the state or national level. An example is Lena Candee Bassette, who began her career as a suffragist. She became New Britain's first female voter and organized a chapter of the League of Women Voters. Active in the Republican Party, she served as the first president of the Women's Republican Club. Her biggest political milestone was being the first woman to run for a seat in the Connecticut House of Representatives. Generally, the owners, directors, and executives of major manufacturing companies served in some sort of local or state public office, some as mayor or even at the state or national congressional level. But there were others who were respected for their work in politics or public office.

New Britain has always had a patriotic population, with many a young man or woman ready to answer the call of duty. There are monuments to veterans everywhere in the city, especially to those who gave their lives for their nation, and there are some that are held dear in the memories of New Britain residents. An example is Joseph White, a drummer boy for the Union army. At the age of nine (and some legends suggest as young as seven), White appeared old enough to enlist, and he successfully signed up with the New Hampshire Volunteers. He served between 1864 and 1865, seeing at least five battles, then came to settle in New Britain. Another Civil War veteran not pictured in this chapter is Francis E. Stanley. He was reputedly the first to enlist in the city when recruitment began in 1861. On April 14, 1863, while an orderly sergeant, he was leading his company against the enemy at Irish Bend, Louisiana, and was killed by enemy fire. His cousin Francis W. Stanley not only shared the same name but was also wounded during the same battle, dying 15 days later.

The abolitionist movement was a long journey for New Britain, with proponents and opponents being most active during the two decades before the Civil War. Minerva Hart was one of the earliest abolitionists in New Britain. She and her husband suffered one of the first, and what appears to be the most violent, mob attacks by opponents. Opponents of the abolitionist movement set fire to the barn of an abolitionist and, during one meeting, repeatedly fired a cannon as a loud protest. The debate of abolitionism versus states' rights divided New Britain, it seems, until the Civil War broke out.

Like Philip Corbin and his car-manufacturing venture, there were pioneers in another form of transportation—aviation. Charles K. Hamilton is the most celebrated in this field locally, and the city always remembers the day he flew his plane here for a massive crowd in Walnut Hill Park in 1910. Nels Nelson, another local aviator, was not as well known. He built his own plane and, like Corbin, dreamed of creating an aircraft-manufacturing center here.

This chapter includes the people of New Britain's past and present who have unique stories to tell or have made contributions to the city or beyond. Some are of popular local lore, and some are known to only a certain group; some have been in national headlines, while others may have been mentioned somewhere in the local paper. The importance of their stories and contributions might vary from person to person, but they are all included here because they represent aspects of the broad and diverse history of New Britain that do not fit the categories of the previous chapters. This is, therefore, a good concluding chapter to this book, illustrating the fact that in a city whose history and legends are often dominated by industry, there are and always will be people who show us that there is much more to the Hardware City.

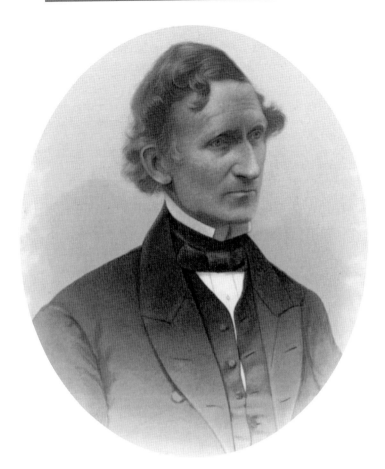

Elihu Burritt (1810–1879)

Burritt was one of 10 children born to shoemaker and Revolutionary War veteran Elihu Burritt Sr. The Burritt children spent most of their youth in their grandfather's silk house, not far from the meetinghouse. Their father died when Elihu was 17, leaving the family without funds to send him to college. So, necessity drove Burritt to become a blacksmith's apprentice, and he spent his free time educating himself with the books in the society library. He excelled at both educations, so Burritt decided to continue his self-education while living in boardinghouses near prominent universities. He would work in a foundry during the day and study in the libraries at night, earning his famous nickname, the "Learned Blacksmith." Turning down a scholarship to Harvard, he instead traveled around the United States and Europe, speaking on everything from abolition to world peace. He was a founder of the League of Universal Brotherhood (the predecessor to the United Nations) and became active in the Peace Congress. He also promoted the "Ocean Penny Postage," a lower international postage cost, to enable the growing masses of immigrants to the United States to maintain ties to their families in Europe. In 1865, he was appointed consular agent for the United States in England, where he remained until 1870. After returning home, he spent his remaining years building church missions and running a small farm. For a long time without a home of his own, he would often stay with friends and colleagues around the city (and reputedly sometimes until wearing out his welcome). It was very late in life that Elihu finally was able to afford the land he had been saving up for—a lot atop what is now Burritt hill. The only college degree Burritt would receive came in 1872, an honorary master of arts from Yale University. By the time of his death, he had mastered some 30 languages. Over the years, many things would come to be named after Burritt, New Britain's most illustrious son. The Burritt Hotel, Burritt Street, Burritt Hill, and the Elihu Burritt Library at Central Connecticut State University are just some of the reminders of the "Learned Blacksmith." (NBHS.)

Elijah Burritt (1794–1838)

Elijah, the older brother of Elihu Burritt, was afforded a college education, and he was just as brilliant in his own fields of study. He authored *Geography of the Heavens*, a landmark map of the stars, which has been long referenced by astronomers. He is often referred to as "the forgotten astronomer," as there is little written about him. He had unusual gifts at mathematics and astronomy and would have likely gone further in his profession if he so chose. Instead, he chose to lead a group of mechanics and artisans to establish a colony known as the Texas Steam Mill Company. Unfortunately, yellow fever broke out and killed most of the settlers, including Elijah and his other brother, William. (NBHS.)

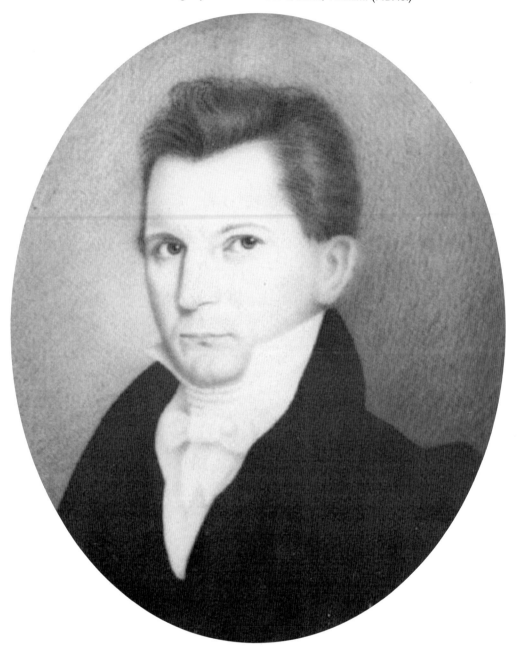

Alfred Andrews (1797–1876)

Andrews spent his busy days teaching, running his farm, and operating his carriage-making business. He taught in the common schools, the church Sunday school, and the academy. His business was a partnership with his brother, called A&E Andrews, which produced wagons, carriages, and iron ploughs. He was an active supporter of the temperance and abolitionist movements, and one of his daughters married fellow temperance worker James Merwin. He was not only deacon of First Church, but superintendent and secretary of the Wethersfield and Berlin Sunday School Union. Active in church work, education, and genealogy, he spent the last years of his life writing his *Genealogy and Ecclesiastical History of First Church of New Britain*, a major source of information on early New Britain. (NBHS.)

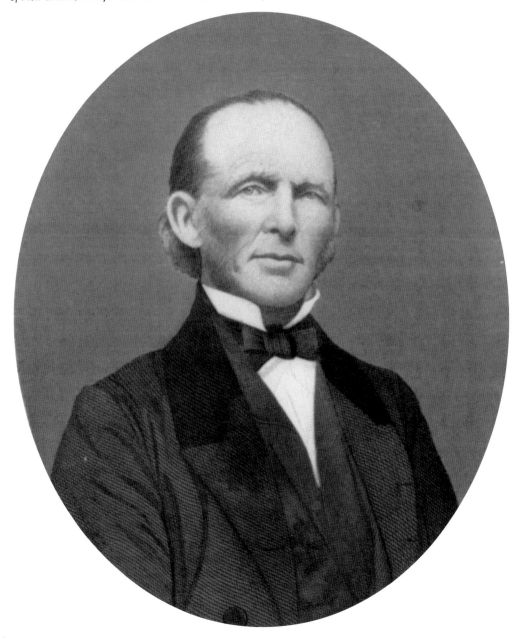

James B. Merwin (1829–1917)

James Merwin was born in Cairo, New York, to Joseph and Emily Merwin. With family ties to the area, James began a career in New Britain as a jeweler at Warner & Lewis. In 1850, he married Margaret Andrews, a daughter of Alfred Andrews and great-granddaughter of Col. Isaac Lee. Influenced by Andrews, Merwin became involved in the Connecticut temperance movement. Bolstered by the prohibition victory in Maine that happened in 1851, Merwin and Andrews helped lead a successful fight for Connecticut's own "Maine Laws." These were enacted in 1854. Merwin was then invited to join the Illinois temperance movement, and, at a convention in Chicago, he met and befriended Abraham Lincoln in 1854. Merwin and Lincoln became close friends while working on temperance legislation in Illinois, although the legislation was not successful and ultimately forgotten due to the Civil War. Lincoln presented Merwin with an engraved watch in 1856 to commemorate their work. Merwin considered that watch to be his most valuable possession. Some years later, when the war broke out, President Lincoln called on Merwin to serve as Army chaplain, to promote not just religion, but temperance among the enlisted men. Lincoln was becoming concerned with the use of whiskey by the men, especially following their paydays, when liquor peddlers would show up to tempt them. The concern was that, should the South find out about it, it would likely time its attacks to the soldiers' paydays and slaughter the intoxicated regiments. Merwin traveled to camps and hospitals all over the Northeast, preaching temperance to soldiers, who were, for the most part, receptive. Lincoln had Merwin ordained and provided him with a handwritten pass that he kept in a daguerreotype case along with a picture of Lincoln. After the war, Merwin moved to St. Louis for a time, and then he was called up again by President Lincoln. Although unsubstantiated due to the loss of records in a fire, legend has it that Merwin became a spokesperson and press agent for Lincoln. The president was working on plans to build a Panama canal amid concern for the thousands of out-of-work freedmen, perhaps considering the two issues together. Merwin, on the day of Lincoln's assassination, was meeting with reporters to reveal these plans. The subsequent assassination and loss of Merwin's records make this one of the great mysteries of New Britain history. (NBHS.)

Lorenzo Deming (1843–1865)

Lorenzo and his brothers Lucius, Julius, and James were born in different towns to a carpenter and clothier, who brought them to New Britain when young. Lorenzo became a mechanic and moved to New Haven, from which city he enlisted in the Navy during the Civil War. His *Picket Boat No. 1* was destroyed while sinking the Confederate ram *Albemarle*, and he was taken prisoner. He was taken to Salisbury, North Carolina, where he died in prison. His remains were thrown into one of 18 trenches, along with the bodies of 11,700 other Union prisoners who had died from disease and starvation at the camp. For 143 years, his grave has been unmarked. In 1992, Lorenzo's descendants placed a memorial headstone (pictured) in Fairview Cemetery. The actions of Lorenzo's Union *Picket Boat No. 1* were noted as being a decisive victory in eliminating a dangerous warship that had sunk many Union vessels. (NBHS.)

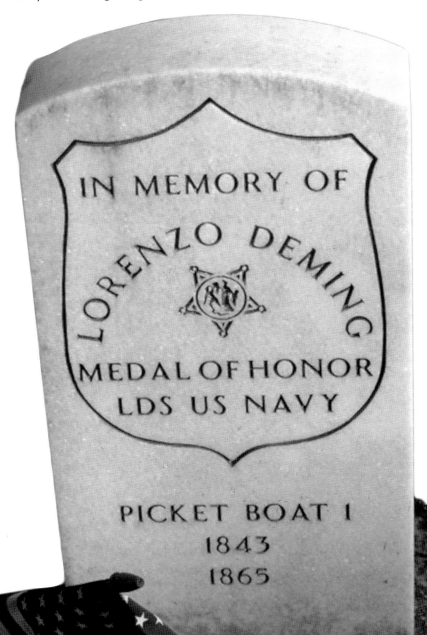

Bassett Family

Seen here is the Bassett-Hart-Doen family at the Bassett home on Main Street. The patriarch of the family, Ozias B. Bassett (1806–1878), was a farmer and a longtime public servant of the village, known for having called the first town meeting by authority of the state legislature in 1850. He married Emeline Eno (pictured in the middle row, left of center), of a prominent family in Simsbury. His son, Milton H. Bassett, was in the Civil War, serving as a telegraph operator and stationed for a time in New Orleans. This afforded Milton Bassett ample time to compose letters, and his writings are considered important historical sources of the Civil War in New Orleans and New Britain, now preserved by the Connecticut Historical Society. (NBPL.)

Valentine B. Chamberlain (1833–1893)

Valentine Chamberlain is known for being a prominent member of New Britain and a Civil War veteran of distinction. Born in Colebrook River, Litchfield County, Connecticut, he was the oldest son of well-known civil engineer Abiram Chamberlain. He was a graduate of Williams College, where he became a friend of future president James Garfield. Having obtained a law degree, he set up practice in New Britain, where his father had previously moved to. He also established the short-lived newspaper, the *New Britain News*, and became the assistant clerk of the House of Representatives in the statehouse. In August 1861, Chamberlain (seated, right of center) enlisted in Company A, Seventh Connecticut Volunteers and became a lieutenant colonel and then captain. In the assault on Fort Wagner in 1863, he was captured by rebel forces and imprisoned for a year and a half. He escaped with a fellow prisoner, hiding in swamps and cabins as they made their way north. Unfortunately, they were recaptured and held until the last days of the war, at which time Chamberlain was paroled. He spent the rest of his life raising a large family and serving in a variety of public offices. After his death, the widow of the Confederate officer who had taken Chamberlain's sword made a valiant effort to return it. She wrote to the *Hartford Courant* and provided what little information she had, mainly where he was captured and when. The Chamberlain family recognized the story; after they made contact, the sword was indeed returned to Valentine Chamberlain's family. (Chris Puffer-Chamberlain.)

Lena Candee Bassette (1872–1957)

Lena Candee was born in Oran, New York, one of five children of Ralph Candee and Anne Sarah Housley. At the age of 11, she moved to Houston, Texas, where she was raised by her aunt and uncle, Mary Elizabeth Housley Felton and George C. Felton. She married Buell Burdett Bassette on June 21, 1893, in Houston, and they had three children. Lena Bassette was a political activist who marched in suffrage parades in New York City, and she spent many hours observing Congress. When she returned to New Britain, she used her political experience to create a gathering place for political activity. Not only was she New Britain's first female voter, she also organized a chapter of the League of Women Voters and served as its first president. She was active in the Republican Party and served as the first president of the Women's Republican Club. Her biggest political achievement was being the first woman to run for a seat in the Connecticut House of Representatives. She was the first society editor of the *New Britain Herald* and was active in many organizations, including New Britain's Woman Club, Boy's Club Auxiliary, the YWCA, the Welfare Committee, the Repertory Theatre, the Burritt Memorial Auxiliary, and the New Britain Musical Club. She was the regent to two DAR chapters, the Dolly Madison Chapter in Washington, DC, and the Esther Stanley Chapter in New Britain. (NBPL.)

Rev. John Klingberg (1867–1946)

John Eric Klingberg was born John Larsen in Saxhyttan, Sweden, to a poor farming family. His family was barely able to survive, but his mother did what she could to compensate for this, teaching John and his siblings the value of hard work. One spring, a fishing-net repairman brought John three books: the New Testament, a catechism, and *The Life and Times of Elihu Burritt*. He believed that God sent him this latter book, and he always had a feeling he would end up in New Britain. At age 18, John moved to a large town and worked in an iron foundry. It was here that he mysteriously changed his name to Klingberg. At age 22, he left to find his way in America, eventually settling in the Swedish district of Chicago. He joined a Baptist church, becoming an ordained minister, and met his wife, Magdalene. In 1900, John Klingberg was offered a pastorship for the Swedish Elim Baptist Church of New Britain. Knowing this was his calling, he moved there and became the pastor, all the while dreaming of what his purpose would be. In 1903, Officer Charles M. Johnson told him that there were three boys living alone in a shack on the edge of town. Klingberg decided to take the boys in, reassuring his worried wife. Still not sure how to support these boys or how to proceed, he prayed and subsequently was offered a house that he could use for a low rent, and another man provided bedding. Thus was the story of the beginnings of the Klingberg home, for years just getting by but always doing so with anonymous donations of food, clothing, and money. Eventually, he would build the Children's Home, now known as the Klingberg Family Center. (NBPL.)

William F. Cody (1846–1917)

"Buffalo Bill" Cody's Wild West Show toured the United States and Europe for three decades. Cody organized his first show in 1883. Occasionally, his show would bring him to Hartford and New Britain, and Cody at some point became aware of the North & Judd Company, which had been producing equestrian hardware. Cody, in need of cash, had patented a horse bit with a pistol shape designed into the cheeks. In 1914, North & Judd began making early versions of the bit, and in 1916, Cody came out to visit. Pictured here are North & Judd president Howard C. Noble in the driver's seat of his 1916 Cadillac Model 53; Buffalo Bill Cody, in the back seat; their New Britain police detail, Patrolman Michael J. Cosgrove; and the five most celebrated Sioux chiefs of Cody's Wild West Show. (NBPL.)

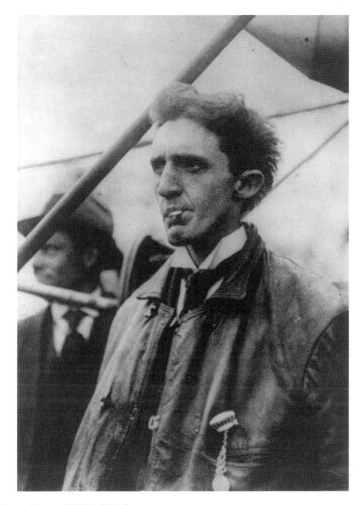

Charles K. Hamilton (1885–1914)
Pictured here, Hamilton walks with his plane as it is pushed along the fields at Walnut Hill Park on July 2, 1910—"Hamilton Day." Although an exciting day for the spectators, this photograph reveals the frustration of Hamilton and his crew. Hoping to set an endurance record, Hamilton found his engine to be quite troublesome, and he was only able to perform three short flights. The first two flights were cut short by a stalling engine, once landing him in a swamp. Although the crowd of over 50,000 people spent much of the day waiting while his mechanics worked feverishly on the plane, they were not disappointed. When Hamilton met the governor at the field, Hamilton was apologetic for what he felt were failed flights. The governor brushed this away, telling Hamilton how proud he and everyone was of him. The governor's pep talk worked, and Hamilton made his third flight. Hamilton was known as a daredevil, and the swooping patterns he made behind hills, loops around the park, and even a low flight down Main Street were unlike anything anyone here had seen before. Born in New Britain, Hamilton spent most of his life as a pioneer parachutist and aviator. Local legend has it that he started his career when a young boy, jumping from a railroad trestle with an umbrella. His first crash was in a dirigible balloon filled with gas; it rose uncontrollably, exploded at a height of three-quarters of a mile, and hurtled back to earth with Hamilton in the basket. It was by sheer luck that the ruptured balloon spread out like a parachute at the last minute, saving his life. It was in 1909 that he joined Glenn Curtiss's exhibition team and began flying airplanes and setting records. He suffered through a number of crashes, but tuberculosis cut his life short in 1914. (NBPL.)

Nels J. Nelson (1887–1964)

Nelson was born in Sweden and immigrated to New Britain as a boy. He started a hobby of building gasoline engines, one of which he mounted to a bicycle, and one of which he would use in his own automobile that he built at age 18. He then began to dabble in aircraft, and ended up being one of the great pioneers of aviation, along with Charles Hamilton. He built a craft similar to Hamilton's Curtiss plane, and in 1911, Nelson made his debut over a crowd of 2,000 spectators in Old Saybrook, Connecticut. His flight ended with a crash, but he was unharmed. Despite this, Nelson built, flew, and sold several Curtiss-type airplanes between 1911 and 1914 in New Britain, actually creating the beginnings of a small industry. At least a dozen persons in New Britain feverishly rushed construction of their own airplanes to take advantage of this novel idea. However, Hamilton's and Nelson's flying skills and Nelson's construction prowess were sure to guarantee success, at least commercially. At the time, however, it was US government contracts that kept aircraft companies in business. Nelson and his partner Aaron Cohen tried but failed to win a contract to build their airplanes, and the fledgling industry faded in New Britain. (NBPL.)

William T. Sloper (1883–1955)

William Sloper was named after his uncle, William Blackwell Thomson. Sloper never did well in school, but he began working at his father's bank and eventually made a good living in finance. Spending the next eight years working in this establishment, Sloper would come to believe he had received a far better education from the real world than he ever could have in college. Foreign travel became a great interest for him, and, as fate would have it, he was on the *Titanic* for its maiden voyage. The memory of this horrific night would remain in Sloper's mind for the rest of his life. Originally purchasing a ticket for travel aboard the *Mauretania*, he was persuaded by some fellow travelers to change his ticket for one on the *Titanic*, which was going to sail three days sooner. Sloper was greeted by an actress, introducing herself as Dorothy Gibson. The night of the disaster, Sloper and Gibson were playing bridge, and this woman would assume the sole responsibility for saving his life in a few hours. Later, when realizing the ship was sinking, Sloper helped Gibson into her lifeboat and, although he was supposed to wait, she became hysterical and demanded he accompany her. What exactly transpired he wrote years later in his book *The Life and Times of Andrew Jackson Sloper*. When he returned home, Sloper angered a reporter that he put off and was then horrified to see a story reporting him as having escaped the disaster by dressing as a woman! This followed him the rest of his life as an urban legend, even though Gibson had independently verified Sloper's account. (NBHS.)

George LeWitt (1890–1960)

Born in New York to Russian Jewish immigrants, LeWitt spent many years of his youth in Hartford and was a graduate of Hartford Public High School. At 20 years old, LeWitt was an aspiring law student at New York University. It was 4:30 on a warm Saturday afternoon, March 25, 1911, when he was at the NYU library. The windows of the law school and library were 15 feet above the roof of the building next door, the Asch Building. A professor and several students, including LeWitt, noticed dozens of hysterical employees from a factory in the building stumbling about on the roof below, and they ran to help. Using ladders positioned between the two buildings, they rescued approximately 69 workers from the 10th floor of what is known as the Triangle Shirtwaist Factory. In 1922, LeWitt moved to New Britain and spent the next 35 years in city government. In addition to being an attorney, he served on the school board and the board of finance and taxation. He was a pioneer motion-picture operator around the state, and his properties included the Russwin Lyceum and Arch Street Theaters in New Britain, the Liberty Theater in Hartford, the Strand Theaters in Old Lyme and Plainville, and the Berlin Drive-In. LeWitt was also a prominent real-estate man and one of New Britain's biggest property holders, owning many pieces of valuable downtown property. He made an unsuccessful bid for secretary of state as a Democrat in 1923. He remained true to his faith his entire life, always active in Jewish relief and civic affairs. American artist Sol LeWitt, founder of the Minimal and Conceptual art movements, was his nephew. George LeWitt hardly spoke of the events of March 25, 1911, or the fact that he had a direct hand in saving the lives of so many people. Picture here is the Brown Building today, formerly known as the Asch Building, which housed the Triangle Shirtwaist Company on the top three floors. NYU Law School was in the adjacent building seen at far left. (NBHS.)

Adolfas Ramanauskas (1918–1957)

Ramanauskas was born in New Britain to a Lithuanian immigrant family, who would later return to their homeland. He studied to be a teacher at the Klaipėda Pedagogical Institute, but, just before graduation, the local area was ceded to Nazi Germany, and the institute was evacuated to another town. The same year, Ramanauskas enrolled in the Kaunas War School, graduating with the rank of second lieutenant in the reserve forces. His class of 1940 was the last class to graduate before Lithuania was occupied by the Soviet Union in June 1940. After graduation, Ramanauskas moved to Krivonys, near Druskininkai, where he became a teacher. He participated in the anti-Soviet June Uprising at the start of the 1941 German invasion of Russia. During the Nazi occupation of Lithuania,

Ramanauskas lived in Alytus and taught mathematics, Lithuanian language, and physical education at the Alytus Teachers' Seminary. As the Red Army was defeating the Wehrmacht, Lithuania was once again occupied by the Soviet forces. Ramanauskas joined anti-Soviet resistance, advancing from platoon commander to chairman of the Union of Lithuanian Freedom Fighters. From 1952, he lived in hiding with fake papers, and he would be the last partisan commander to be captured. Betrayed, he was arrested, tortured, and eventually executed by the KGB. After Lithuania regained independence in 1990, Ramanauskas was posthumously awarded the Order of the Cross of Vytis and promoted to brigadier general. (Ministry of National Defence Republic of Lithuania, through GNU Free Documentation License, Version 1.2.)

World War II Production Workers

New Britain was part of one of America's primary Ordnance Districts after the outbreak of World War II. This meant that the city's factories would be called upon to produce military hardware, often with unfamiliar requirements. As seasoned workers joined the military, the rest of the city's men and women were called upon to produce this hardware. These heroes of the home front worked to ensure that the heroes abroad would have the best equipment possible. (Library of Congress.)

Robert Stanley Barton (1925–2009)

Born in New Britain, Barton is best remembered as the chief architect of the Burroughs B5000 and B1700 computers (pictured here). He received the first Eckert-Mauchley Award from the Association for Computing Machinery and the Institute of Electrical and Electronics Engineers (IEEE) for "outstanding contributions in basing the design of computing systems on the hierarchical nature of programs and their data." He was also named a Computer Pioneer Charter Recipient by IEEE for his work in computer architecture. (NBHS.)

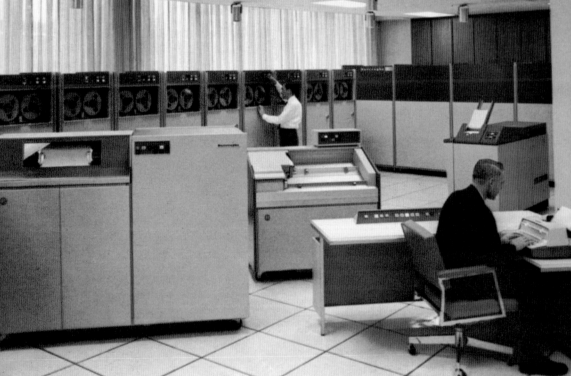

John T. Downey

A New Britain native, John Downey graduated in 1951 from Yale University. Downey decided to serve his country as part of the CIA; while he could not tell his family about this service, John was suddenly called away to work abroad. Downey and partner Richard G. Fecteau were assigned in November 1952 to a mission flying an anti-Communist Chinese agent out of China. They were shot down over Manchuria; Downey and Fecteau survived, only to be taken prisoner by Communist forces. Back home, the government could only tell Downey's family that he was missing on a downed commercial flight from Korea to Japan. They would wait a year before being told that he was presumed dead. As another year went on, hope faded for Mary Downey, John's mother. But suddenly, his name was among a list of 13 prisoners broadcast by China in November 1954. This provided her a sudden mix of hope and fear; with the news of his survival came the news that he was sentenced to life in a Chinese prison. The state and federal governments took on the task of seeking the release of Downey and Fecteau, but they were granted only small concessions—an invitation to visit, assurances of humane treatment, and an exchange of letters. The Chinese government, especially hostile to America for fighting their allies the North Koreans, saw more political motivation to keep Downey than to release him. Thus, months turned into years, and the first decade went by, with hope again fading. The secret nature of Downey's affiliation with the CIA only further complicated matters, as the government had to insist he was a civilian. John's mother would continue to press for his release, occasionally aided by others. John (seated, right) is shown here being visited by his mother, brother, and sister-in-law during a 1971 visit. The photograph was taken by a Chinese Red Cross worker. It was not until March 1973, a year after Nixon began reestablishing ties with China, that Downey's captors saw a political motivation to release him. Unfortunately, just a few days before his release, Mary Downey suffered a stroke. But she pulled through and even asked to be stood up when he came to visit her at the hospital. (NBHS.)

Father Jerzy Popieluszko (1947–1984)
In a grove of trees in Walnut Hill Park stands a large and striking steel and stone monument. This monument, in the shape of a flame with stones at its base, is dedicated to Father Jerzy Popieluszko. He took part in the struggle for freedom and human rights in Poland, weaving his sermons with criticism of communism and motivation for protests. In October 1984, Popieluszko was beaten and murdered by Communist police officers, which only caused an uproar and furthered the resolve of the anti-Communists. As in other American areas with significant Polish populations, New Britain created a monument to the city's support and remembrance of Popieluszko and Poland's struggle for freedom. During a visit to New Britain in 1996, Lech Walesa paid tribute to the priest's monument by placing a fieldstone among the others in the base. (Both, NBHS.)

Dr. David Krech (1909–1977)
Born in Russia, Krech came to live in New Britain as a boy. He studied psychology at New York University and then at the University of California, Berkeley, experimenting with the process of learning and behavior. He would go on to study brain chemistry and how it, and its modification, can affect learning, memory, and intelligence. He spent much of his life teaching at UC Berkeley until his retirement in 1972. (Department of Psychology, UC Berkeley.)

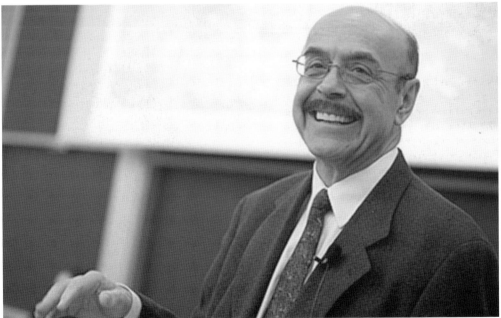

Dr. Christopher Winship
Christopher Winship, son of Monty Winship, grew up in New Britain. In 1977, he received his PhD in sociology from Harvard. He was a professor of sociology, statistics, and economics at Northwestern University from 1980 to 1992. Subsequently, he returned to Harvard as the Diker-Tishman Professor of Sociology. His research spans a range of topics, including causal inference, community policing, and changes in the social and economic status of black Americans. (Harvard Photo Services.)

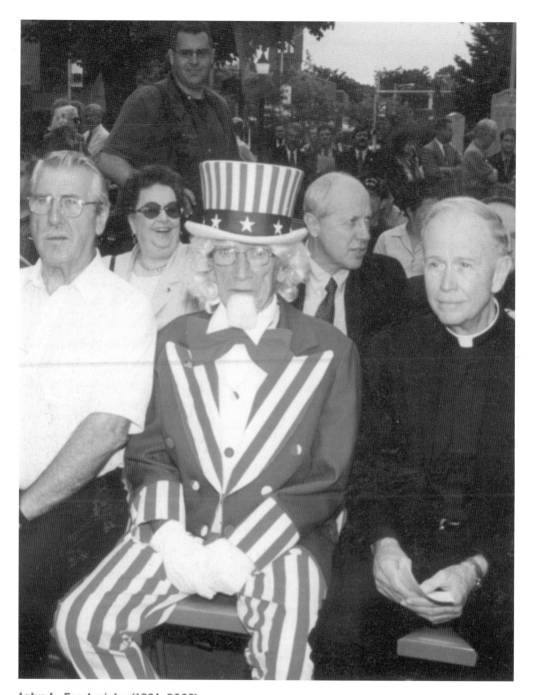

John L. Fredericks (1921–2003)

Fredericks, a New Britain native and veteran of World War II and Korea, was known for his tireless work with numerous election campaigns and organizations. He is probably best remembered for his portrayal of Uncle Sam in parades and public functions in New Britain and beyond. He was on hand in this capacity during Pres. Ronald Reagan's visit, having even obtained FBI clearance to stand next to Reagan. (Sylvia Fredericks.)

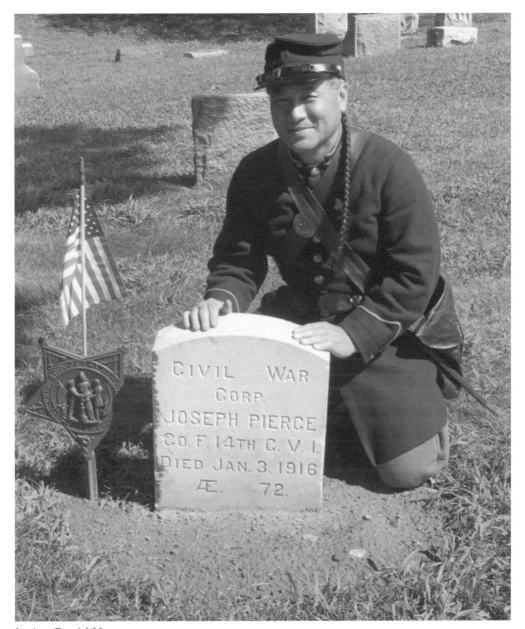

Irving David Moy
Recently retired as a public health services manager for the State of Connecticut, Irving Moy is the president of Company F, 14th Connecticut Volunteer Infantry. This is a preservation and reenactment organization dedicated to the Civil War company of that name, based out of Hartford and comprised largely of New Britain men. Moy has done much valuable research into this unit, as well as into the life of Joseph Pierce. (Irving Moy.)

BIBLIOGRAPHY

Andrews, Alfred. *Memorial: Genealogy and Ecclesiastical History.* Chicago: A.H. Andrews, 1867.

Bickford, Christopher P. *Farmington in Connecticut.* Canaan, NH: Phoenix Publishing, 1988.

Camp, David. *History of New Britain, with Sketches of Farmington and Berlin, Connecticut, 1640–1889.* New Britain, CT: William B. Thomson & Co., 1889.

Comstock, John B. *Fifty Years of Progress, History of the House of P.&F. Corbin MCMIV.* New Britain, CT: P&F Corbin, 1904.

Deming, Judson. *Genealogy of the Descendants of John Deming of Wethersfield, Connecticut.* Dubuque, IA: Mathis-Mets Co., 1904.

Domizio, Albert F. *New Britain and the Civil War.* New Britain, CT: Author, 1977.

Fowler, Herbert E. *A Century of Teacher Education in Connecticut: The Story of the New Britain State Normal School and the Teachers College of Connecticut 1849–1949.* New Britain: Teachers College of Connecticut, 1949.

———. *A History of New Britain.* New Britain, CT: New Britain Historical Society, 1960.

Mitchell, Deacon Charles E. *One Hundred and Fiftieth Anniversary, First Church of Christ.* New Britain, CT: First Church, 1908.

Osborn, N.G. ed. *Men of Mark in Connecticut: Ideals of American Life Told in Biographies and Autobiographies of Eminent Living Americans.* Vol. III. Hartford: William R. Goodspeed, 1907.

Sloper, William Thomson. *The Life and Times of Andrew Jackson Sloper.* New Britain, CT: Author, 1949.

Tryon, Lillian Hart. *The Story of New Britain, Connecticut.* New Britain, CT: Esther Stanley Chapter DAR, 1925.

Workers of the Federal Writers' Project of the Works Progress Administration for the State of Connecticut (CT FWP). *Connecticut: A Guide to Its Roads, Lore, and People.* Boston: Houghton Mifflin, 1938.